Russian Decorative Painting

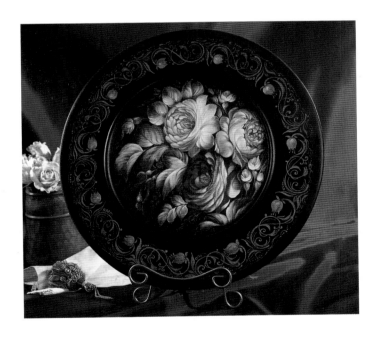

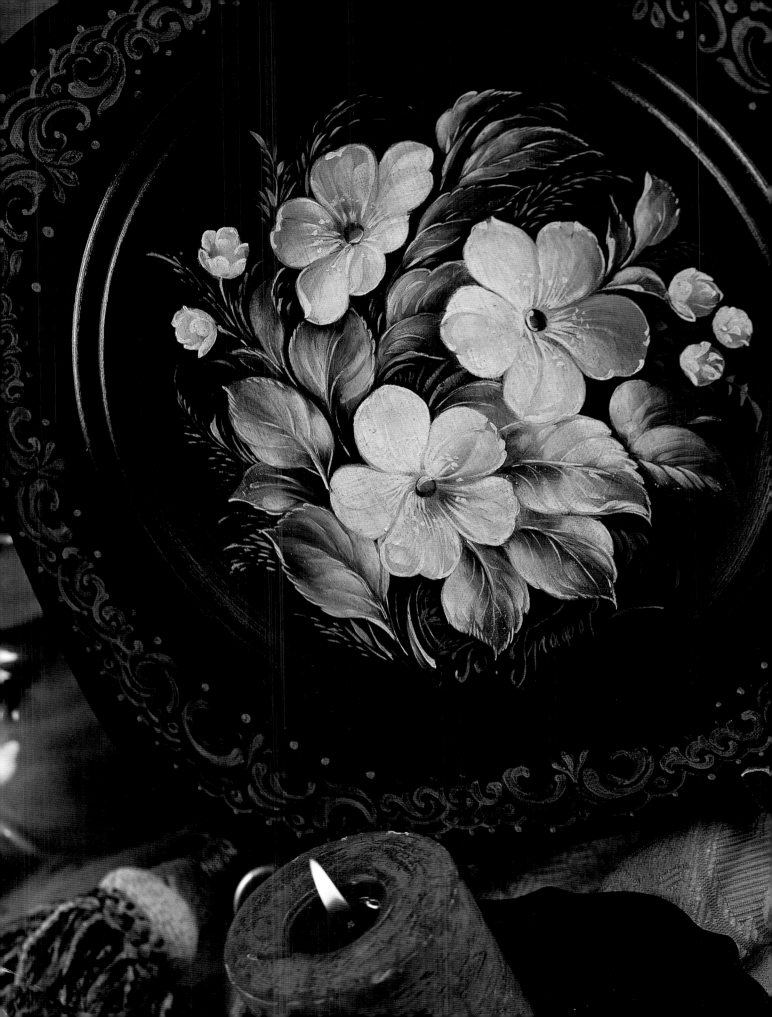

Russian Decorative Painting

TECHNIQUES & PROJECTS MADE EASY

Priscilla Hauser & Boris Grafov

Sterling Publishing Co., Inc.
New York

Prolific Impressions Production Staff:

Editor in Chief: Mickey Baskett
Copy Editor: Ellen Glass
Graphics: Dianne Miller, Karen Turpin
Styling: Lenos Key
Photography: Jerry Mucklow
Administration: Jim Baskett

Library of Congress Cataloging-in-Publication Data Available

2 4 6 8 10 9 7 5 3 1

Published by Sterling Publishing Co., Inc.
387 Park Avenue South, New York, NY 10016
©2006 by Prolific Impressions, Inc.
Distributed in Canada by Sterling Publishing
c/o Canadian Manda Group, 165 Dufferin Street,
Toronto, Ontario, Canada M6K 3H6
Distributed in the United Kingdom by GMC Distribution Services,
Castle Place, 166 High Street, Lewes, East Sussex, England BN7 1XU
Distributed in Australia by Capricorn Link (Australia) Pty. Ltd.
P.O. Box 704, Windsor, NSW 2756, Australia

Printed in China
All rights reserved

Sterling ISBN-13: 978-1-4027-1474-0
 ISBN-10: 1-4027-1474-2

For information about custom editions, special sales, premium and corporate purchases, please contact Sterling Special Sales Department at 800-805-5489 or specialsales@sterlingpub.com.

Acknowledgements

A special thanks to the following manufacturers for furnishing products for painting the projects in this book:

Robert Simmons for artists' brushes
Martin F. Weber for Permalba® Professional Oil Colors
Plaid Enterprises, Inc. for FolkArt® Acrylic Colors
Mastersons for the Sta-Wet® Palette

Special Thanks

Barbara Saunders has been my right hand in writing this book. She has studied under Boris and has been a teaching aid during our Zhostovo painting classes. She has helped me adapt the Russian style to available products. She worked very hard on the text of this book, the painting of the step by step worksheets, and the drawing of the design patterns. This book couldn't have been done without her help.

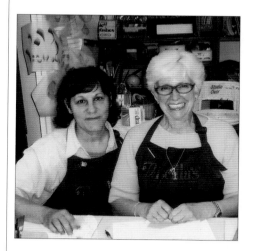

About the Artists

Priscilla Hauser and Boris Grafov

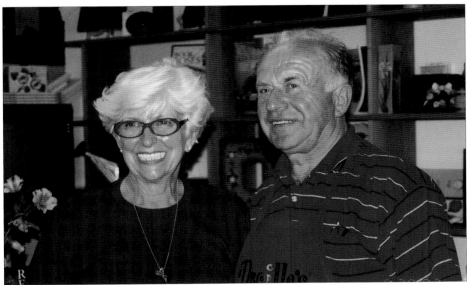

Priscilla Hauser and Boris Grafov take a break from teaching a Zhostovo painting class at Priscilla's Studio by the Sea, Panama City, FL.

Priscilla Hauser, Master Decorative Painter

Priscilla Hauser has been teaching and promoting decorative painting for more than 40 years. She has appeared on numerous TV shows, has written hundreds of books and magazine articles, and has traveled the world to learn about the history and techniques of all forms of decorative painting.

Priscilla discovered Boris Grafov and the charming town of Zhostovo, where he was a master painter in a tray factory, during an educational trip to Russia to learn more about their decorative painting. Enchanted with this lovely Russian folk art form of decorative painting, Priscilla brought this art to the United States. In 1992, Priscilla made it possible for a group of Russian painters from Zhostovo to come to the annual convention and trade show of the Society of Decorative Painters. Many painters fell in love with this art of floral painting and have been students of this work since then. Boris is such a popular teacher that Priscilla continues to bring him to the United States each year to teach classes at her "Studio by the Sea" in Florida.

Priscilla has been successful at translating Boris' traditional Zhostovo technique into a teachable technique that could be understood by all decorative painters. Not only has she introduced the oil painting technique to students, she also has been able to convert the technique for use with acrylics. With the help of Priscilla's teaching skills anyone can learn this beautiful floral painting art.

For more information about classes at Priscilla's Studio by the Sea, see her website at www.priscillahauser.com.

Boris Grafov

Boris Vasilyevich Grafov is known as an honorable Merited Artist of Russia. He has been decorated with medals of the Academy of Arts, and has won diplomas and awards at numerous exhibitions of different levels in Russia. His acclaim has also reached the world outside of Russia. Boris was one of six artists who were chosen to go to Belgium in 1958 to represent Russian art. He won a Silver Medal for his work. His work is highly valued in the United States where he teaches and sells his paintings to collectors. Mr. Grafov studied at the Zhostovo school in Russia from 1947 to 1950. He worked two more years as an artist in the factory before taking a four-year leave to serve in the Navy. When he returned to the school he took a leadership role. Mr. Grafov has been Zhostovo's permanent Artistic Director and Chief Artist since 1961.

Mr. Grafov has received many medals from the National Artist of Russia Awards:

1959 Gold Medal and two Silver Medals
1970 Gold Medal
1978 Silver Medal
1996 Gold Medal

In Russia, Boris Grafov is recognized as a national treasure. His works are exhibited by major national museums. It is with great pride and admiration that we feature Mr. Grafov's techniques and designs in this book.

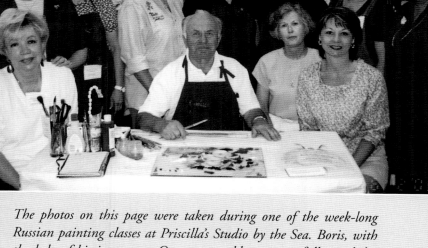

The photos on this page were taken during one of the week-long Russian painting classes at Priscilla's Studio by the Sea. Boris, with the help of his interpreter Oxana was able to successfully teach his Zhostovo style of painting. Priscilla Hauser and her staff have adapted his painting style to products that are available in the United States.

"This book represents happiness, love, harmony, life, feelings of holidays, and poetic expressions, and it calls out to everyone to try it."

Boris Grafov

In 2002, Boris Grafov and I published our first book on the Russian folk art painting of the artists in Zhostovo, a small town outside of Moscow. The book, along with the classes, demonstrations, and lectures given at my Studio by the Sea in Panama City, Florida, introduced this elegant ornamental artwork to decorative artists and students from all over the world. They loved it as much as I do.

After a few weeks of studying the traditional styles and techniques of Zhostovo painting, the artists continued to develop them in their own artwork after they left. They shared their enthusiasm with their own colleagues and students all over the world – Australia, Canada, Japan, Argentina, the United States and more.

Zhostovo artwork is a feast for the eyes. The elaborate compositions of flowers, fruits, and leaves appear impossibly complex, but the basic concepts are easy to learn. The process can be broken down into easy steps: 1) loading the brush, 2) mixing colors, 3) stroking on the shadows and highlights, and 4) ornamenting with the graceful linework that makes the Zhostovo style distinctive. When presented in this manner, most anyone can be successful.

We continue to exhibit fine examples of Zhostovo work and teach the techniques at the Studio by the Sea. Boris Grafov is not only a master painter, he is an inspirational teacher. Several times a year, Boris joins us to teach classes and develop more designs.

This book includes complete instructions for ten projects painted on wood and metal surfaces. The step-by-step photos and the full-color painting worksheets make it possible for someone who is new to Russian folk art painting to learn the techniques and paint beautiful pieces in the Zhostovo style.

Whether this is your first exposure to this gorgeous art form, or you are an experienced painter seeking new patterns, I hope this book will inspire you to begin painting today.

Priscilla Hauser

Contents

The vibrant Russian folk art paintings from Zhostovo, a small town outside of Moscow, have inspired a passionate response from decorative painters all over the world. In this book, Priscilla Hauser, a master teacher of decorative painting, translates traditional designs, colors, and techniques into patterns and step-by-step instructions that can be learned by any decorative painter. She developed the designs and processes in collaboration with Russian master painter Boris Grafov, Artistic Director and Chief Artist of the Zhostovo school. This is their second book that teaches the Zhostovo style of decorative painting.

The book begins with information and photos of supplies and painting techniques such as brush loading, brush strokes to create shading and highlighting, and painting fine linework and ornamental borders. Step-by-step painting photos and full-page staged worksheets complement the detailed instructions.

Roses, tulips, chrysanthemums, berries, and blossoms are gathered into richly colored designs for ten projects painted on wood and metal surfaces. The complete instructions cover every step from surface preparation to final varnishing, so any painter can learn this art. The book closes with a chapter of beautiful close-up photos of Zhostovo pieces from private collections.

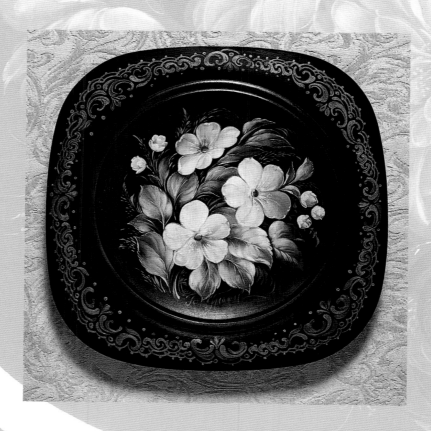

INTRODUCTION
Page 10

Supplies for Zhostovo Painting

Brushes, paints and mediums, surfaces, and finishes.
Page 12

General Information
Page 20

Painting terms, techniques for shading and highlighting, painting ornamental linework and borders, and finishes. Includes photo demonstrations for painting leaves and a rose.

The Projects

Collectors' Gallery
Page 107

An array of brilliant Zhostovo pieces from private collections.

From Zhostovo to the World

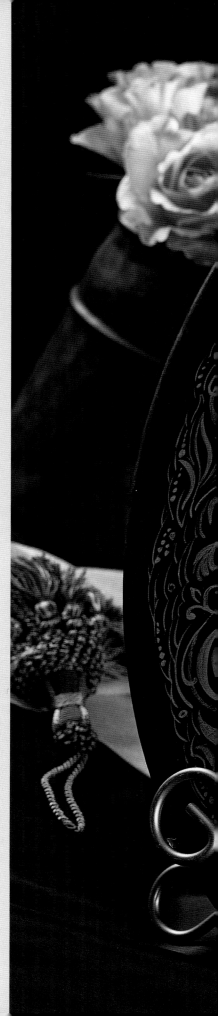

When Priscilla Hauser brought a collection of Russian folk art paintings back to the United States in 1992, she brought the art of Zhostovo to the attention of decorative painters all over the world. Zhostovo (pronounced jhos-TO-vo) is a village near Moscow that is a center of development for a vibrant style of Russian folk art painting. The village is known for its dark, usually black, lacquered metal trays painted with bright arrangements of flowers, fruits, and leaves. The trays are embellished with painted gold and silver filigree borders and trim.

These enchanting trays belong to the tradition of Russian miniature paintings on lacquered papier mache, whose history goes back to the 18th century. When Ossip Filippovich Vishnyakov opened his workshop in Zhostovo in 1825, he offered hand-made and hand-painted boxes, cigar cases, snuff boxes, and other papier mache items including trays. In addition to floral decoration, these early pieces were painted with landscapes, genre scenes, and scenes of troika driving in the countryside. (A troika was a small Russian carriage drawn by a team of three horses.)

The Vishnyakov workshop and other painting workshops in the village soon began to specialize in producing the metal trays for which they are best known today. At first they painted realistic garden and field flowers. The style developed as a folk art, combining the imaginary with the real to create brilliant, joyful blossoms. The style is fresh, direct, and heart-felt, and was immediately popular. Zhostovo trays were always prized as ornaments, hung on walls and displayed on shelves.

The highly trained craftsmen of Zhostovo brought a high level of artistic design and painting skill to their subjects. That tradition continues. In a President's Decree dated the 6th of November 1993, Zhostovo folk art was added to the State Index of the most valuable objects of culture of the Russian Federation.

Each and every tray painted by Zhostovo's master artists is one of a kind. The artist preserves the best traditions and enhances them with his own improvisations. The artist never paints the same bouquet twice. In fact, because the oil paints are brush-mixed on the palette, every petal and leaf is unique. Zhostovo art is no longer confined to one small town outside the Moscow suburbs. Today the art can be seen in museums, galleries, exhibitions, and private collections all over the world. Not only the items, but also the style of painting has spread widely, as enthusiastic decorative painters share the techniques with their colleagues and students.

Priscilla Hauser's Studio by the Sea continues to be a center for teaching and exhibiting Zhostovo style painting. We think you will enjoy learning it, and will agree that this Russian folk art is one of the most beautiful in the world.

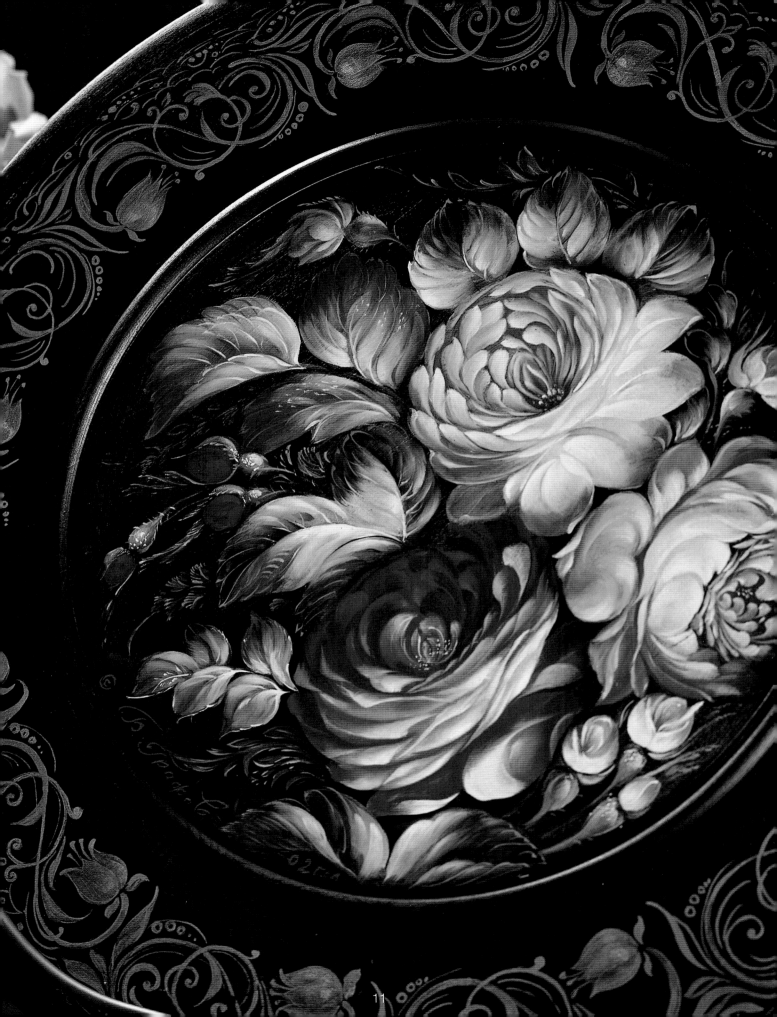

Supplies for Zhostovo Painting

Traditional Zhostovo artists used oil paints and made their own squirrel hair brushes to create their vibrant paintings on tin trays. Today, decorative artists all over the world are learning to paint in this distinctive folk art style. They may choose to paint with oils or acrylic paints and they will certainly purchase their brushes rather than make them.

The materials you will need are listed in this chapter. Paints, brushes, varnishes, and a few additional supplies are readily available. Gather the materials and begin your own adventure in Russian folk art painting.

Paint

Zhostovo paintings are prized for the luminous colors of their decorative patterns. Most artists today paint in the traditional manner with oil paints. However, it is possible to achieve a similar effect with acrylic paints. The color palette is the same for oils and acrylics.

The Color Palette

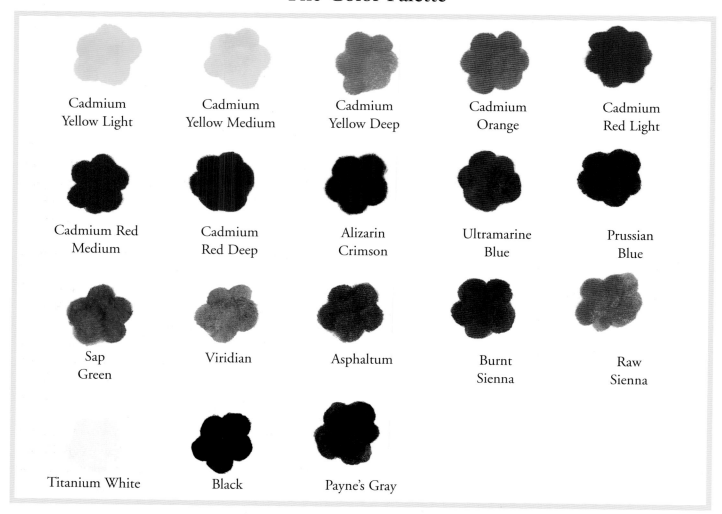

Cadmium Yellow Light Cadmium Yellow Medium Cadmium Yellow Deep Cadmium Orange Cadmium Red Light

Cadmium Red Medium Cadmium Red Deep Alizarin Crimson Ultramarine Blue Prussian Blue

Sap Green Viridian Asphaltum Burnt Sienna Raw Sienna

Titanium White Black Payne's Gray

The authentic palette of the Zhostovo artists consists of the following oil colors. The color palette is the same, whether you are using oils or acrylics to paint the design.

1. Cadmium Yellow Light (CYL)
2. Cadmium Yellow Medium (CYM)
3. Cadmium Yellow Deep (CYD)
4. Cadmium Orange (CO)
5. Cadmium Red Light (CRL)
6. Cadmium Red Medium (CRM)
7. Cadmium Red Deep (CRD)
8. Alizarin Crimson (AC)
9. Ultramarine Blue (UB)
10. Prussian Blue (PB)
11. Sap Green (SG)
12. Viridian (V)
13. Asphaltum (ASP)
14. Burnt Sienna (BS)
15. Raw Sienna (RS)
16. Titanium White or Zinc White (TW) or (ZW)
17. Black (B)
18. Payne's Gray (PG)

Oil Paints & Mediums

The designs on the surfaces in this book are all painted with oil paints.

A painting medium is a product used with the paint to affect its consistency (thin it), to help the paint move or flow, or to affect its opacity. When using oil paints, **linseed oil** is the usual medium. To make even thinner paint, linseed oil and **turpenoid** may both be used. The thinner you want the paint to be, the more turpenoid you use in the mix.

Acrylic Paints & Mediums

If you choose to paint the design with acrylics, the quality of artists' tube acrylic paint is best for painting in the Zhostovo style. You will find tube acrylics in art supply

stores. Craft acrylics, usually packaged in squeeze bottles, have a different formulation.

Undercoating the design as well as **basecoating** the project surface may be done with craft acrylics. You will find craft acrylics in hobby and craft stores.

Painting mediums for acrylic paints include blending medium, floating medium, and glazing medium.

You will need a "sta-wet" type of palette. Acrylic paints dry very quickly, and this palette, when properly prepared, will keep your paints wet throughout your painting session. These palettes may be found at most art and craft stores. A brush basin is handy for rinsing and cleaning brushes used with acrylics.

Differences Between Oil Paints and Acrylics

Traditionally, Zhostovo painters have used oil paints for their designs, but you can use acrylic paints if you prefer. Many tube acrylics as well as some bottled acrylics have pigment color names that are equivalent to the pigment color names given to oil paints. This makes it easy for you to substitute acrylics for oils when you are following the painting instructions.

It is important to remember that you cannot use oils and acrylics together. Either paint the entire painting with acrylics or paint the entire painting with oils. (Undercoating is different – you can paint with oils on top of a dry acrylic undercoated surface.)

The two types of paint are significantly different in formulation and handling properties. One of the most important differences to the painter is drying time – acrylics dry very quickly compared to oils. The drying time affects the amount of "open" time the artist has – how much time the paint can be worked on the surface before drying begins to impede it. They are chemically different; oils and acrylics require different painting mediums and different cleaning solvents for your brushes.

When dry, acrylics have a flat finish while oils have a natural sheen. This is not as noticeable, however, once a varnish is applied to the dried design.

Brushes and Their Care

Zhostovo artists paint with Russian squirrel hair brushes that are shaped very much like filbert brushes. The brushes are difficult to find in this country and are not available in numbered sizes. They are simply small, medium, and large. These brushes must be broken in before use because the more they are used, the smoother your strokes will look. The traditional Zhostovo artist makes his own liner brush. It is a long hair squirrel brush that is trimmed with a razor blade to create a brush that looks something like a wet noodle. It takes a little time and practice to learn to use this brush for linework and ornamentation, but the results are excellent.

Filbert brushes are readily available and can be substituted for the Russian squirrel hair brushes. These synthetic hair brushes are recommended in sizes #2, #4, #6, #8, #10 and #12. You will also need an excellent #1 and #10/0 liner or scroll brush.

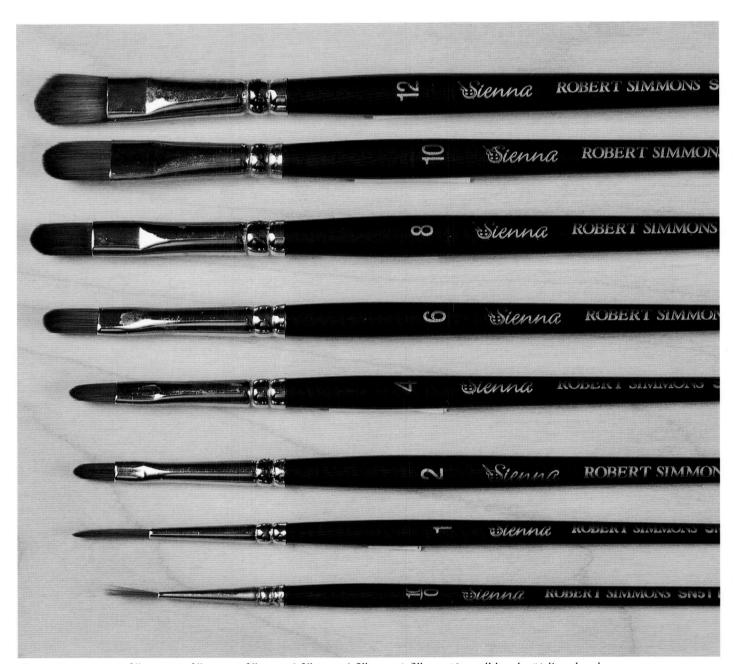

Top to Bottom: #12 filbert, #10 filbert, #8 filbert, #6 filbert, #4 filbert, #2 filbert, #2 scroll brush, #1 liner brush.

Brush Care for Synthetic Brushes

Most fine brushes come with a sizing in them – a stiffening agent that keeps every hair in place. Remove the sizing before you begin to paint. Hold the brush between your thumb and forefinger and gently work the brush back and forth. You will notice the sizing flaking out of the brush. Clean the brush in soap and water and dry it before using.

You can dress the brush in linseed oil before you begin painting just as you would the squirrel brushes.

When you have finished painting for the day, clean the brush in turpenoid and wipe it on an absorbent towel. Place a small amount of liquid detergent in a container and work the brush back and forth in it until you have gotten every bit of paint out of the brush. Rinse the brush with water until you no longer get paint or soap out of the brush. Put a small amount of clean soap back into the brush and shape the hairs of the brush. When you are ready to paint again, simply rinse the brush in water to remove the soap. Remove the water with a soft, absorbent paper towel or cotton cloth.

Brush Care for Squirrel Hair Brushes

Dip new squirrel hair brushes in turpenoid, blot on a soft, absorbent towel, and dip into linseed oil. Work the oil through the brush by stroking it back and forth on the glass palette.

Use your brush as often as you can. When you do so, you condition the brush, breaking it in so the brush can actually help you create perfect strokes.

After painting, if you plan not to use your brush for just a day or two, you can dress it with linseed oil. If you plan to leave your brush three to five days, dress it with olive oil. If you are planning to store your brush and not use it for a while, dip it into automotive motor oil – yes, the kind you put in your car. This oil will not dry out in the brush. Add a moth crystal to the storage container to prevent pests from eating the natural hair bristles.

When you take your brushes out of storage, dip them into a separate container of turpenoid to remove the motor oil. When the motor oil is cleaned out of the brush, you can dip the brush into linseed oil. Label this container of turpenoid, keep it separate, and do not use it during your painting. If you get the motor oil into your paints, the painting will not dry properly.

Boris Grafov suggests that you do not wash squirrel hair brushes in soap and water because it will interfere with the shape of the brush.

Motor oil and olive oil for brush care.

TIPS:
- All brushes must be in excellent condition in order to perform well.
- If the brush is too frizzy on the edge, rub the brush with a little linseed oil back and forth on a piece of fine grade sandpaper. This will actually sand off the fuzzy edge.

Surfaces for Painting

Traditional Zhostovo artists painted on metal trays. Today, artists are painting on many different surfaces ranging from furniture to refrigerators. Many of the projects in this book are painted on wooden surfaces, including plates, trays, boxes, and even tables.

Preparing Wood Surfaces

When working with wooden surfaces, repair any imperfections with wood filler. Let the wood filler dry and sand the surface with fine sandpaper. Wipe off sanding residue with a tack cloth.

Here's How:
1. Seal the surface with a brush-on sealer or spray it with a clear matte acrylic spray and let dry.
2. Basecoat with two or three coats of acrylic paint, drying after each coat. Sometimes more than two coats of paint are needed, depending upon the opacity or transparency of the paint. After each coat, sand the surface with a very fine grade of sandpaper and wipe off the sanding residue with a tack cloth.
3. Seal the surface again with a light coat of sealer or matte spray.
4. Do a final sanding with fine sandpaper or rub with a brown paper bag with no printing on it. Remove all residue with a tack cloth.
5. Transfer your pattern following the instructions in the "General Information" section.
6. Undercoat only the design with white acrylic paint.

Preparing Metal Surfaces

If you can, purchase a surface that has been commercially prepared. If your surface is raw, unprimed tin:
• Wash it thoroughly with dishwashing detergent and water, rinse well, and let dry.

• Wipe the surface with vinegar.
Basecoat the metal surface by spraying or brushing on two or three coats of a flat metal primer paint. If you spray, please make sure you do it outdoors on a warm day in a well-ventilated area. I suggest you wear a respirator or face-mask while spraying. Many light coats of spray are better than one heavy coat.

Here's How:
1. Shake the can.
2. Hold the can 8" to 10" from the surface.
3. Try to spray when the temperature is around 70 degrees. If the temperature is too hot, the spray will dry in the air and will be powdery when it hits the surface. If this happens, you will have to sand the surface with 4/0 steel wool and spray again. (In Florida, we have to spray very early in the morning to avoid this problem.)
4. Let dry and sand with very soft steel wool after each coat. Remove the residue with a tack cloth before applying the next coat.
5. Make sure you sand the last coat with a crumpled-up piece of brown paper bag with no printing on it. This gives a very smooth surface. Remove any residue with a tack cloth. Seal with matte acrylic spray. Rub lightly again with the brown paper bag. Wipe with a tack cloth. Let dry and cure.
6. Transfer your pattern following the instructions in the "General Information" section.
7. Undercoat only the design with white acrylic paint.

TIPS:
• Always work in a well-ventilated area.
• It is important to mist many light coats of clear acrylic spray rather than one coat that is too heavy. Do not over-seal the wood and make it so slick that your decorative painting will not adhere!
• Sealing the prepared surface before you put your pattern on will allow you to clean up any errors without disturbing your basecoat.

Varnishes

Authentic Zhostovo pieces are finished with a very high gloss, oil-based varnish applied over the decorative painting. You may choose oil-based varnish or water-based varnish to finish your pieces. (Water-based varnish can be used over oil paints.)

Apply many light coats of varnish instead of one heavy coat.

If you are using brush-on varnish, apply it with a good quality varnish brush. If you are working on a light colored background, be sure to use a non-yellowing varnish.

Spray varnish can also be used. When using aerosol sprays, wear a respirator and apply many light coats, drying after each coat.

TIPS FOR APPLYING VARNISH:

- Sign and date your completed painting.
- Be sure the painted item has thoroughly dried and cured before varnishing.
- Before varnishing, rub the painted piece with a piece of brown paper bag with no printing on it to absorb any excess oil that may be on the surface.
- It is best to varnish with both the piece and the varnish at room temperature.
- Allow each coat of varnish to dry. Sand lightly with a very fine grade of sandpaper or steel wool, or rub with a brown paper bag. Remove residue with a tack cloth before applying the next coat.
- Three, four, five or more coats of varnish may be applied, as desired. Do not sand the final coat.

Additional Supplies You Will Need

Glass palette for oil paints
Sta-wet palette for acrylic paints
Palette knife for breaking out the paints and for mixing colors
Color wheel for reference
Tracing paper for tracing patterns to be transferred to the surface
White and colored blackboard chalk or **chalk pencils** for transferring patterns (Do not buy the dustless kind.)
Stylus for transferring patterns
Eraser for removing unwanted pattern lines
Soft, absorbent paper towels or cotton cloths for cleanup
Compass optional for drawing circles
Tack cloth for wiping away sanding dust
A good brush for basecoating
Linseed oil as an oil paint medium
Olive oil for brush care and storage
Motor oil for preserving brushes between painting sessions
Turpenoid – An odorless, colorless turpentine substitute. Use it for thinning paint, cleaning brushes, and removing paint. Painting properties and drying time are similar to those of turpentine.
Glass jars, one for clean turpenoid, one for cleaning brushes, and one for cleaning motor oil out of stored brushes
Brush basin and **water** for rinsing and cleaning brushes used with acrylics
Sandpaper and **brown paper bag** for preparing wood surfaces
Wood sealer for preparing wood surfaces
Fine steel wool (0000) for preparing metal surfaces
Clear acrylic spray, matte finish – One option for sealing wood, also used to protect the undercoating before painting the design.
Single-edged razor blade to scrape undercoating for smoothness
Bridge – A ruler or piece of wood to use across the project to keep your arm out of the wet paint.

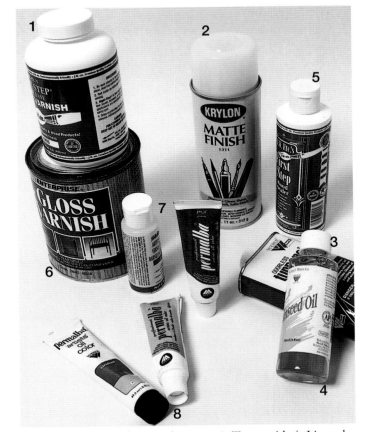

1. Gloss varnish, 2. Clear acrylic spray, 3. Turpenoid, 4. Linseed oil, 5. Wood sealer, 6. Polyurethane gloss varnish, 7. Blending medium for acrylics, 8. Oil paints

General Information

In this chapter, you will learn how to prepare your palette and how to load your brushes. Step-by-step photos will show you how to make various strokes and how to shade and highlight your design. A list of painting terms and their meanings will teach you to understand and speak the language of painting.

It's up to you to practice, practice, practice! Remember when you learned to drive a car? At first your attention was on your hands and feet, on shifting gears or signaling turns. Only when these activities became automatic could you focus your attention on where you were going. It's the same with painting – when the mechanical actions of loading the brush and stroking the surface become comfortable habits, your attention can be focused on the painting itself. Study a little and practice a lot. You will find that your confidence increases as your skills improve, and you will be ready to begin your own Zhostovo style painting.

Terms to Know

Artists' Tube Acrylic paint: These are the fine art tube acrylics found in art and some craft stores. The chemical formulation of these paints is different in many cases than the bottled craft acrylic paints.

Basecoating: The application of acrylic or oil paint to the surface of the item on which you will be painting your design. Apply several coats. Sand with a fine grade of sandpaper after each coat and wipe with a tack cloth. You need to achieve a smooth, opaque surface before you transfer the design and begin to paint.

Brown paper bag: Rubbing the surface with a piece of brown paper bag with no printing on it smoothes the surface and eliminates the need for sanding. A piece of brown paper bag is non-abrasive but does a beautiful job of smoothing a surface.

Brush Mix: The difference between brush mixing and mixing on the palette is that with brush mixing there is color already in the "dirty" brush, so you will achieve variations in the color, depending upon what color is already on the brush. To brush mix two colors, dip the dirty brush into the first color, blend on the palette, dip into the next color, and blend on the same spot on the palette.

Acrylic Craft Paint: Craft paint is used for basecoating. Occasionally, people use it to paint the Zhostovo designs.

In this book, however, craft paint is only used for undercoating the design.

Dressing the Brush: This means to fill your brush with a painting medium before picking up the paint color. For oils, this medium is linseed oil and sometimes turpenoid as well. Acrylic paint mediums are blending medium, floating medium, and glazing medium.

Dirty Brush: A brush that is not cleaned between loading colors. It is wiped on a soft cloth or paper towel to remove excess paint before loading a different color.

Grass: "Grass" refers to the graceful fill-in strokes around the flowers and leaves in Zhostovo designs. It is generally done with the liner brush and very thin paint.

Highlighting: This is adding a lighter color in the areas which receive more light to add form to the object.

Linework: These are the fine lines of a painting – details or outlining painted with a liner brush and thinned paint.

Mixing a Color on the Palette: Using a palette knife to mix the colors together to get the proper tint. This is done by placing two or three colors in puddles on the palette close to one another and mixing with a palette knife. Usually darker colors are mixed into the lighter colors until the desired tint is achieved.

Paint Consistency: This refers to the thickness or thinness of the paint. Most of the time, paint needs to be slightly thinned with the appropriate medium so it will "move" and have the proper consistency for painting. To thin paint, dress the brush with the medium, pick up paint, and stroke it on the palette.

Shading: Sometimes called "shadowing," this is adding a darker color in the areas which receive less light to add form to the object you are painting.

Stippling: In this work, to stipple is to apply small dots randomly throughout an area (such as a flower center), using the very tip of a liner brush.

Tack cloth: This is a piece of cheesecloth treated with varnish and linseed oil. It is used for wiping away sanding residue and lint. You will find tack cloths in paint, hardware, or craft stores. Store your tack cloth in a glass jar with a lid.

Undercoating: Painting the design area solidly with white acrylic craft paint before beginning to paint the colors of the design. This allows the design colors to be bright and vibrant against the background color of the piece.

Preparing Your Palette

The color palette generally follows the color wheel. Referring to a color wheel for the order, squeeze a small puddle of paint of each color you will need onto your palette. As you use up a puddle of paint, add more as needed in the same spot on your palette.

You will brush-mix the oil colors on your glass palette. For instance, if you need an ice blue color, pick up some White and a touch of Prussian Blue from their puddles and, in a clean spot on your palette, mix the two colors together with your brush to create the ice blue color.

The project instructions will tell you which colors you will need to put in puddles on your palette. When a mixed color is required, instructions will tell you which colors to mix together to create that color.

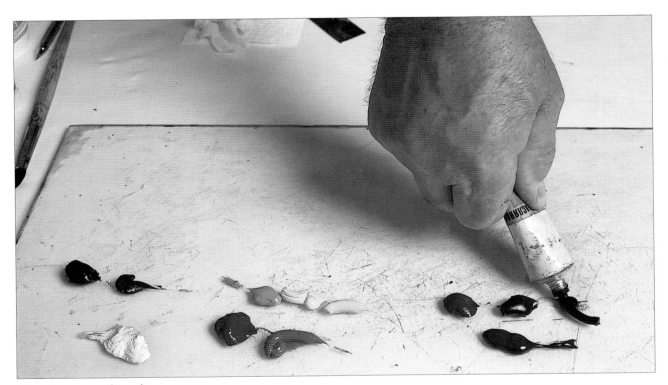

Preparing your color palette.

Transferring the Pattern to Your Surface

1. Place tracing paper over your design or pattern. Using a fine point marking pen or a pencil, carefully trace the design.

2. Turn the paper over. Neatly trace the lines of the pattern on the backside of the tracing paper firmly with chalk or a chalk pencil. Never rub chalk all over the back of the pattern! (See Photo 1.)

3. Shake off excess chalk dust, center the pattern on the project surface with the chalked side down, and secure it with tape.

4. Retrace the lines with a pencil or stylus to transfer the chalk lines to your surface. Don't press hard enough with the pencil or stylus to make indentations in the surface. (See Photo 2.)

5. When your design has been painted and allowed to dry, remove any visible pattern lines with a kneaded eraser or a little water before applying the varnish.

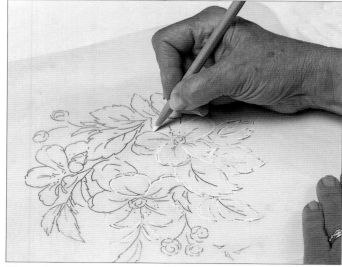
Photo 1

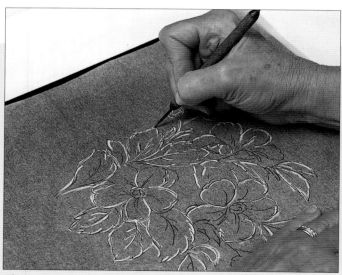
Photo 2

TIPS:

- Graphite or carbon lines often show through your painting and are difficult to remove. They may leave irremovable smudges on the background.
- If your background is medium to dark in color, use white chalk on the back of your tracing paper. If your background is light, use brown or green chalk – a color you can see.
- Use a photocopier to enlarge or reduce patterns so they will fit your chosen surface. Trace the copies and transfer as above.

Undercoating

Undercoating is painting the design area solidly with white acrylic craft paint. Most of the Zhostovo designs are painted on a dark background. Before the rich colors are applied, the entire design area is painted with white. This coat of white gives illumination to the completed painting. In other words, light reflects through the oil colors to create an elegant brilliance. Russian painters use white oil paint for undercoating. They place the trays in large drying ovens overnight. We can get very similar effects by undercoating with acrylic craft paint and allowing the undercoating to dry before painting.

Oil paints may be applied over an undercoating of thoroughly dried acrylic paint. However, when painting the design, do not mix oil and acrylic colors. Paint the design with either all oils or all acrylics.

Use the largest brushes possible to undercoat each

element of the design so that you will avoid lots of brush stroking. Stroke in the same direction and manner you will use to paint the design. If you are not sure what size brush to use for undercoating, refer to the instructions for the brush size used to paint the design. Do not undercoat the linework.

Here's How:

1. Smoothly undercoat the entire design (except the linework) with white acrylic craft paint, using the same directional strokes you will use to paint the design. Allow the paint to dry thoroughly. (See Photo 1.)

2. Gently scrape the surface of the undercoated design with a single-edged razor blade to remove any ridges from the white acrylic paint, and to make the surface smooth and even. Hold the razor blade straight up to keep from cutting into the surface. Wipe off any residue. (See Photo 2.)

3. Rub with a piece of brown paper bag with no printing on it. Wipe off the residue with a soft cloth. (See Photo 3.)

4. If you will be painting with oil paints, apply a very thin layer of linseed oil to the undercoating with a small piece of cotton cloth. (See Photo 4.)

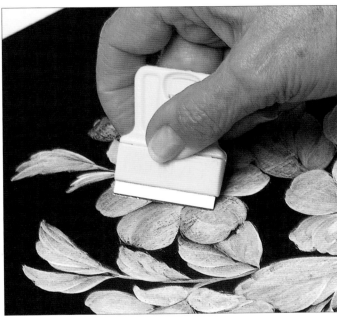

Photo 1

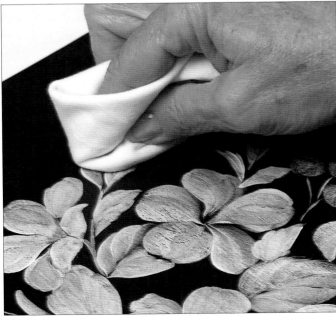

Photo 2

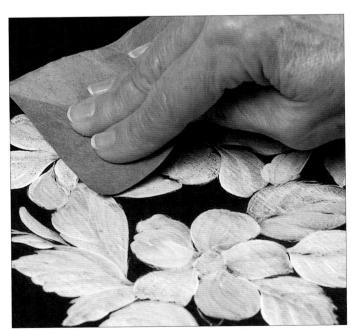

Photo 3

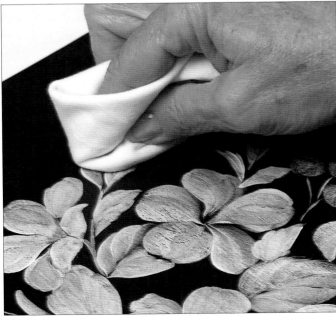

Photo 4

Loading Your Brush

Much of the success of your painting depends upon learning the proper techniques for loading your brush. Use the filbert brushes to paint the flowers and leaves. Use the liner brushes to add details such as leaf veins, vines, and tendrils as well as borders.

When painting a single element such as a leaf or a flower, the brush is used "dirty" (see "Terms"). You can dip it into linseed oil after loading colors on the brush if the brush seems too dry and does not move easily. Swish brushes in turpenoid and blot them on a soft cloth or paper towel to lightly clean them between the painting of design elements. For example, after painting the leaves, swish the brush into turpenoid and blot it before loading colors to paint the flower.

Basic Sideloading

A sideloaded brush is used to form the shapes of petals on flowers, or for stroking highlights on leaves or flowers.

1. Pick up a color on one side of a dressed brush. Stroke one-half to one-third of the brush through the color.
2. Turn the brush over and stroke on the other side of the brush in order to get enough paint in it. Blend on the palette. The color should gradually fade through the hairs of the brush

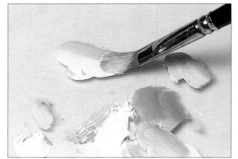

Photo 1

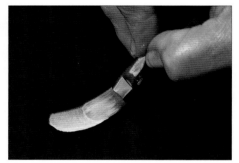

Photo 2

from dark to light. (See Photo 1.)
3. As shown with this brush stroke, the color is darker on one side and fades out. (See Photo 2.)

Brush Mix

This is done with a dirty brush. Dip the brush into the first color and brush it onto a clean spot on the palette. Dip the brush into the next color and take it to the spot on the palette where the first color was applied. Brush back and forth on this spot to blend and mix the two colors. The difference in brush mixing and mixing on the palette is that with brush mixing there is paint already in the "dirty" brush so that you will achieve variations in the color, depending upon what color is already on the brush.

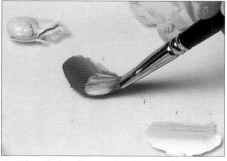

1. Blend the first color by stroking on a clean spot on the palette.

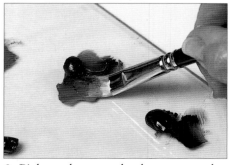

2. Pick up the second color on one edge of the brush.

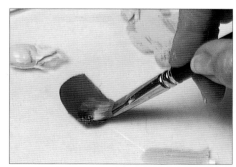

3. Mix the two colors together on the palette.

Full Brush Loading

If you are using oil paint, most of the time you will need to thin the paint a little to make it brush consistency. You do this by "dressing your brush" with linseed oil before loading it with paint.

1. Dip the brush into linseed oil.

2. Blot the brush on a paper towel.

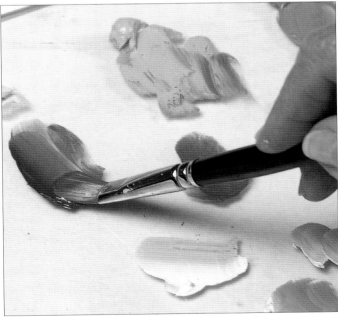

3. Go back to the palette to thin the paint. The paint is now brush consistency and ready for painting.

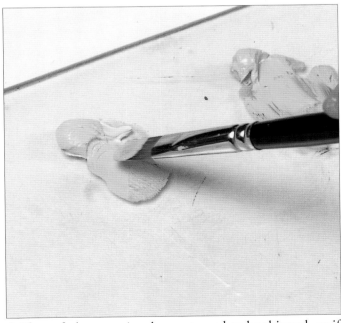

4. If you feel your paint does not need to be thinned, or if you want a heavy load of paint, fully load the brush by simply pulling paint from the puddle with the tip of the brush.

Loading a Liner Brush

Linework is done with very thin paint. It should flow from the brush as you pull the brush along. A mixture of half turpenoid and half linseed oil is generally used to thin oil paints to the proper consistency for using a liner brush. If you want a thinner consistency, use more turpenoid than linseed oil.

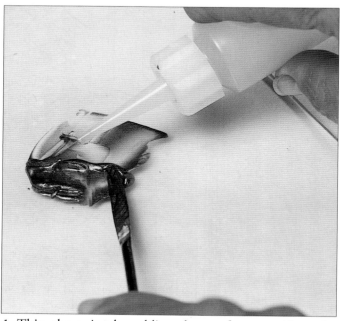

1. Thin the paint by adding drops of turpenoid to the puddle of paint on your palette.

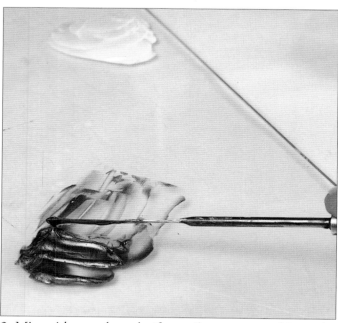

2. Mix with a palette knife until you get a thin, inky consistency.

3. Fill the brush completely full by pulling paint from the puddle into the brush. As you pull the brush from the puddle, twist and twirl the brush so the tip remains finely pointed.

4. Paint the linework by holding the brush upright, pulling the brush along on its tip.

Basic Overview

Procedure

The sequence of creating a Zhostovo painting is as follows:
1. Sketch or trace and transfer the design.
2. Undercoat the design areas.
3. Rub on a thin coat of linseed oil. *(For oils only.)*
4. Paint the first shadows.
5. Paint the second shadows.
6. Add the medium value color.
7. Stroke in a lighter value and the highlights.
8. Add fine lines in and around the design elements.
9. Add ornamental linework around the design – the grasses.
10. Paint the borders (known as ornamentation).

This process requires many layers of paint. The first layers are very thin and seem like tints on the surface.

Background Colors

Traditional colors for the backgrounds of Zhostovo trays are dark cherry, dark brown, dark green, dark blue, and, of course, black. Today painters use many variations of these colors. Sometimes they even combine colors, fading one color into another.

The projects in this book are painted on surfaces that have been basecoated with two or more layers of black acrylic craft paint. Oil paints may be applied over dried acrylic paint. However, when painting the design, do not mix oil and acrylic colors. Paint the design with either all oils or all acrylics.

Using a Bridge

Oil paint stays wet for a long time. This gives you a longer open time for blending colors, but it also increases the possibility of smearing the paint. To avoid smearing, support your hand on a "bridge" when you are painting. A bridge is simply something on which you can rest your hand while it spans across the painting. A sturdy ruler or strip of wood will suffice.

Stroke Linework & Ornamentation

Zhostovo's traditional linework is used in a number of ways. One form of linework is the creation of beautiful, very thin and flowing filler strokes, often referred to as "grasses." These graceful, flowing lines are often painted between leaves and often around the petals of flowers to fill in and soften the painting.

When you paint the grasses, mix several colors from the palette to make a gray color. It may be a gray-blue or a gray-brown. By mixing together colors used in other parts of the design, the grass color always relates to the rest of the design.

Linework is also used to embellish and add details to flower petals, flower centers, stems, buds, and leaves.

Linework can only be created if the liner brush is full of paint that is a thin and flowing consistency.

Linework Tips:
- Fill the brush completely with paint thinned to a flowing consistency.
- Hold the brush so the handle points straight up toward the ceiling.
- Move the brush slowly, allowing the paint to flow from the hairs of the brush.

Boris Grafov uses a bridge to support his hand while painting.

TIPS FROM BORIS
How to Keep Your Colors Crisp and Clean:
- Apply one color of the design at a time instead of painting one subject at a time.
- Keep your palette clean by scraping off the muddy paint with a palette knife or razor blade.
- When reloading your brush, first wipe it on a cotton cloth to remove the remaining paint.
- Clean your brush in turpenoid and wipe it on a soft, absorbent cloth between color changes. You may need to add linseed oil to the brush again before picking up the next color.
- If you are having problems keeping your colors clean, use a different brush for each color.
- Use clean turpenoid when mixing colors or thinning the paint consistency.

Painting Borders

The border work in Zhostovo painting is stunning. The gorgeous combination of commas, dots, and linework produces exciting and elegant frames that compliment the beautiful floral designs.

Traditionally, the borders are painted with gold metallic paint. Occasionally, they are painted with silver metallic paint. However, other pigments can be used as well. Borders can also be created using bronzing powders and gold leaf.

I have had very good results using acrylic metallics to paint the borders. This paint dries quickly, which helps me keep from smearing the wet paint as I go around the surface, building the borders.

Painting S-strokes, C-strokes, or teardrop strokes in combination will create the ornamentation or borders. Usually one kind of stroke is repeated around the entire border, then the next type of stroke is added to the previous row until you build the size border you want. To add dots to a border, dip the handle end of your brush into the thinned paint, then touch it to the surface.

Refer to the "Loading a Liner Brush" section to see an example of border painting with a correctly loaded liner brush.

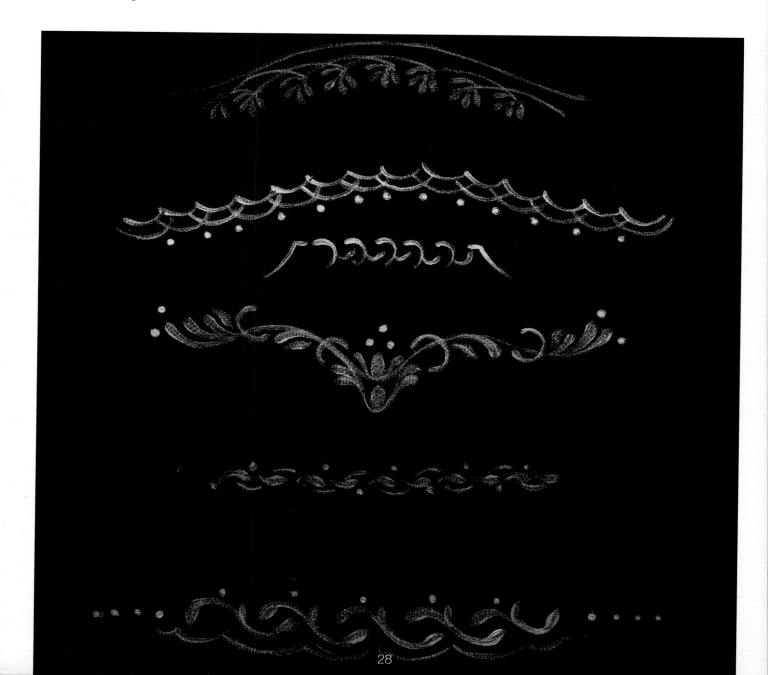

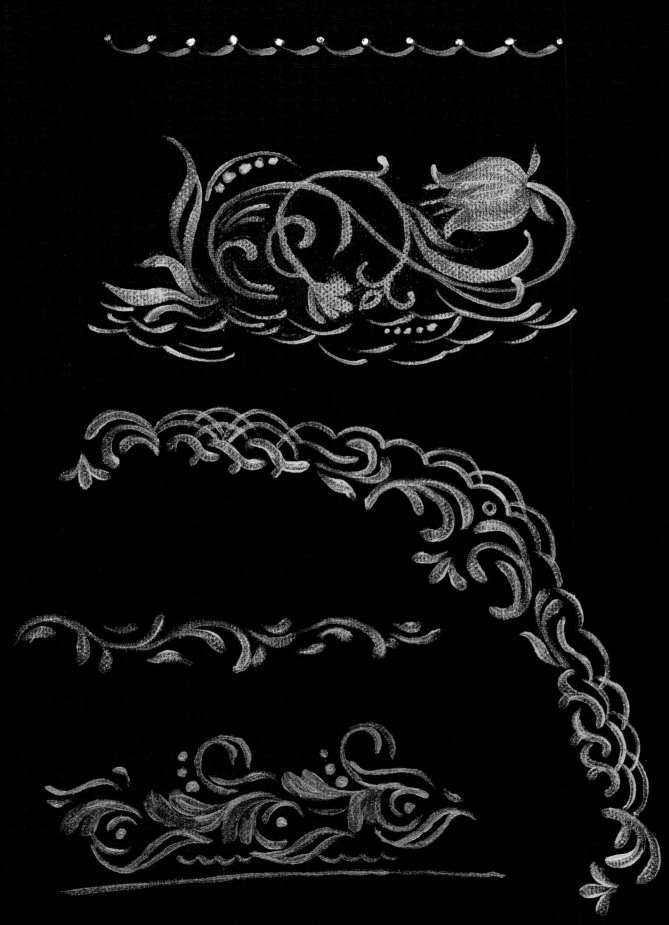

Borders

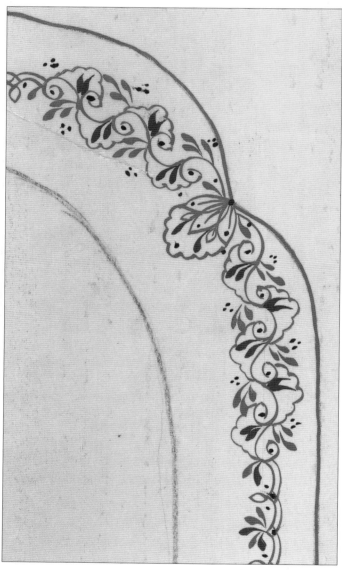

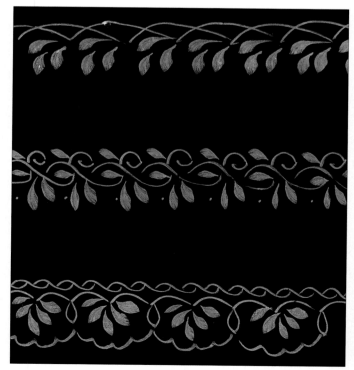

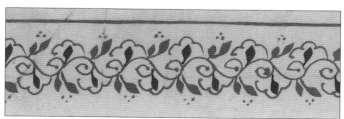

Linework Filler Ornamentation Painting Worksheet

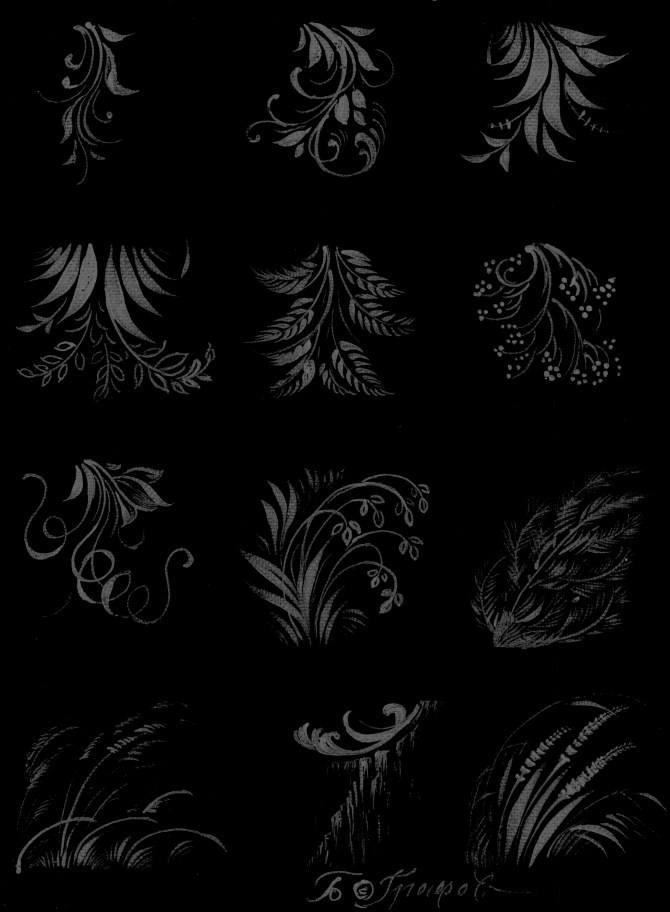

Painting Leaves

While Zhostovo leaves vary dramatically in color, they are all painted with a similar technique. Usually there are both warm and cool colored leaves in a design, to add contrast and visual excitement. Don't be afraid to experiment with color. Look closely at the photos of finished pieces in this book for inspiration.

You will use the colors and brush sizes that are specified in the instructions for each project, but the basic technique is the same for all leaves: Brush on the first layer of colors, then define the leaf shape by adding S-strokes while the first layer is wet. The S-strokes pick up some of the wet paint underneath to create attractive color variations in the leaves. This mixing of layered colors means that in Zhostovo painting, no two leaves are the same.

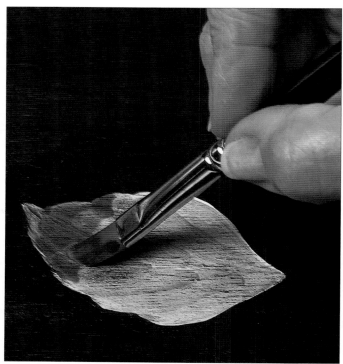

1. Lay in the color on the tip of the leaf. In this case it is Alizarin Crimson. Wipe the brush.

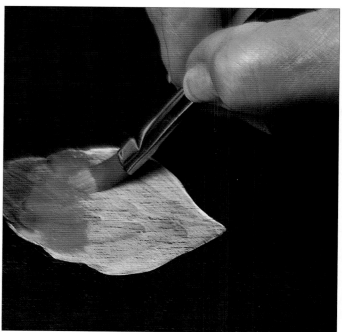

2. Lay in the next color – in this case it is Cadmium Yellow Medium. Blend the two colors together where they meet. Wipe the brush.

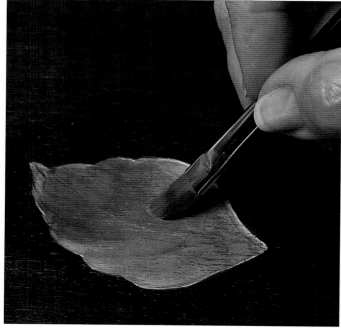

3. Brush green color over the entire leaf, covering the other colors. In this case Sap Green is brushed over the leaf.

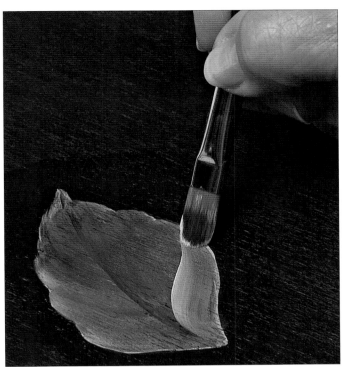

4. Using the tip or side of the brush, add the vein color to define the dark vein area. Here Viridian is mixed on the brush that already has Sap Green in the bristles.

5. Add a little White to one side of the dirty brush. Define the leaves by making S-strokes, beginning at the vein and pulling out toward the edge of the leaf.

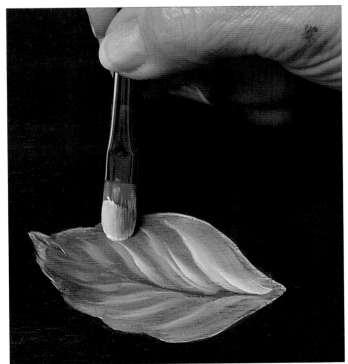

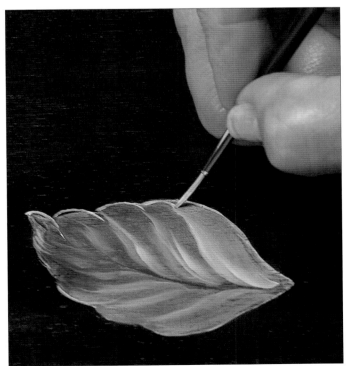

6. Add more White to the dirty brush and mix on the palette. Further define the leaves by making S-strokes as you near the base of the leaf.

7. Paint the White highlights along the edge of the leaf using the liner brush.

Basic Leaf Painting Worksheet

Illustration A
Undercoat with White
acrylic paint. Let dry.

Illustration B
Brush Alizarin Crimson on
the tip of the leaf.

Illustration C
Brush Cadmium Yellow Medium in
the center area of the leaf. Blend softly
where the colors meet.

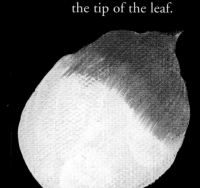

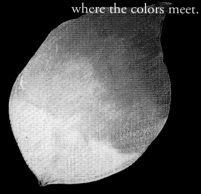

Illustration D
Brush Sap Green over
all the leaf.

Illustration E
Brush mix Sap Green +
Viridian. Add the vein.

Illustration F
Add White highlights and linework.

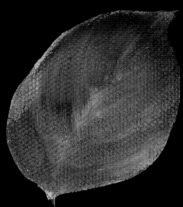

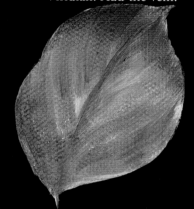

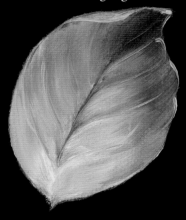

FALL LEAF:

Illustration A
Undercoat with White and brush Alizarin
Crimson on the tip, as above.
Brush Cadmium Yellow Deep in the center
of the leaf. Blend where the colors meet.

Illustration B
Add Cadmium Orange on
one side. Stroke in the vein
with Cadmium Orange.

Illustration C
Add White highlights and linework.

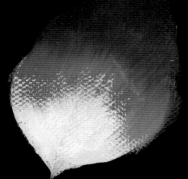

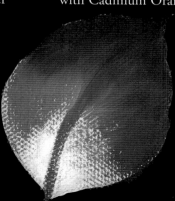

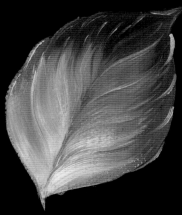

Blade Leaf Painting Worksheet

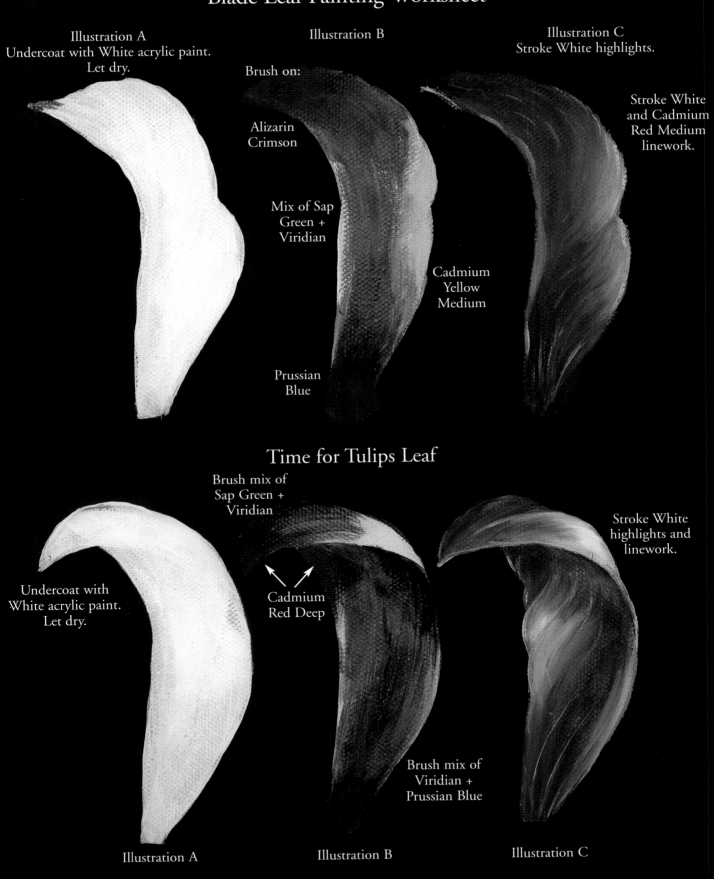

Illustration A
Undercoat with White acrylic paint. Let dry.

Illustration B

Brush on:

Alizarin Crimson

Mix of Sap Green + Viridian

Cadmium Yellow Medium

Prussian Blue

Illustration C
Stroke White highlights.

Stroke White and Cadmium Red Medium linework.

Time for Tulips Leaf

Undercoat with White acrylic paint. Let dry.

Brush mix of Sap Green + Viridian

Cadmium Red Deep

Brush mix of Viridian + Prussian Blue

Stroke White highlights and linework.

Illustration A

Illustration B

Illustration C

Painting a Rose

Follow master painter Boris Grafov as he paints a rose. The result looks magical, but it is painted one step at a time. With practice, your projects will bloom with magical roses, too.

COLOR PALETTE FOR DESIGN

Asphaltum
Alizarin Crimson
Burnt Sienna
Cadmium Orange
Cadmium Red Deep
Cadmium Red Light
Cadmium Yellow Medium
Titanium White

OTHER SUPPLIES

Acrylic craft paint:
 White
Brush-on or Spray Paint:
 Flat black (for basecoating background)
Brushes:
 Small filbert brushes (#2, #4 or #6)
 Medium filbert brushes (#8 or #10)
 Large filbert brushes (#12 or #14)
 Liner (#1, 10/0) or scroll brush
Mediums:
 Turpenoid
 Linseed Oil
Painting Surface:
 Large wooden plate

HERE'S HOW

1. Undercoat the entire transferred design with white acrylic paint, using the same strokes you will use to paint the design. Let dry. Gently scrape the undercoating with a single-edged razor blade. Hold the razor blade straight up to keep from cutting into the surface. Rub with a brown paper bag. Wipe off any residue. Apply a very thin layer of linseed oil to the undercoating.

2. Lightly feather in Asphaltum + Cadmium Yellow Medium for the first shading. Wipe the brush.

3. For the second shading, apply Cadmium Red Deep on top of the yellow.

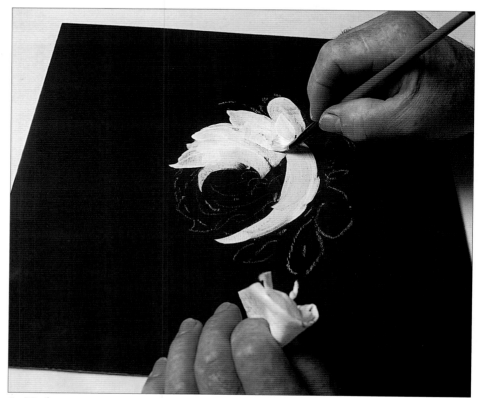

1. Undercoat

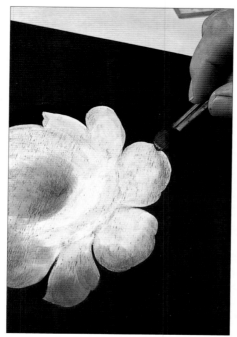

2. First shading

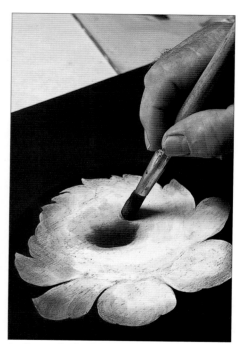

3. Second Shading

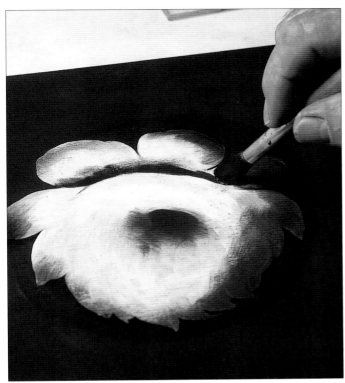

4. Shape the lower bowl with Cadmium Red Deep. Wipe the brush.

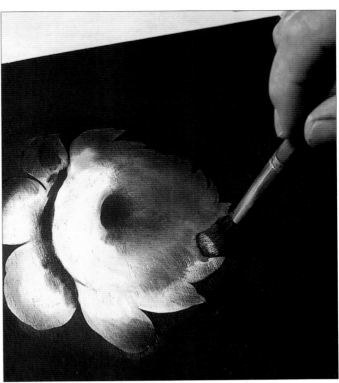

5. Fill in the rose with Cadmium Red Light, blending in all colors.

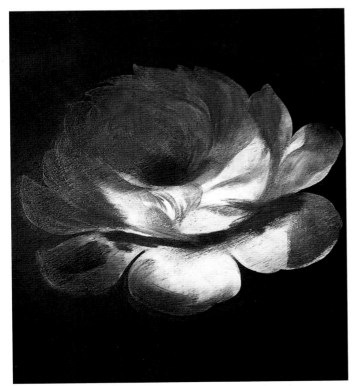

6. As you fill in, shape the petals. Wipe the brush.

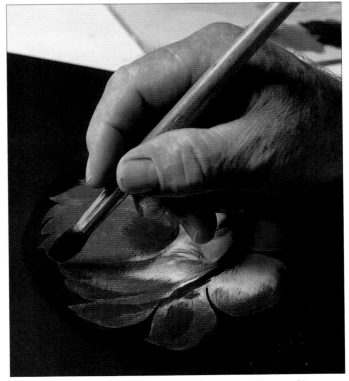

7. Lay in deep shadows with Asphaltum + Burnt Sienna + Cadmium Red Deep to form petals.

continued on next page

Painting a Rose, continued from page 37

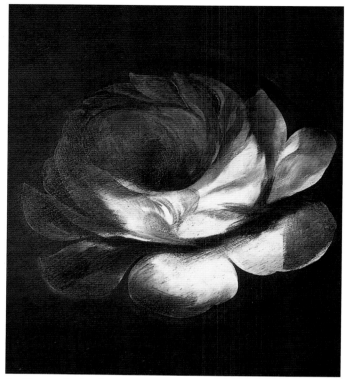

8. Shape the back petals with the deep color.

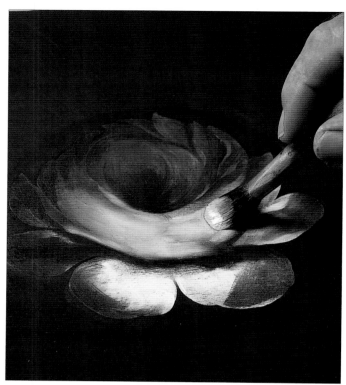

9. Fill in the medium value on the front of the rose and the front petals with Titanium White + Cadmium Red Light. Blend as you go.

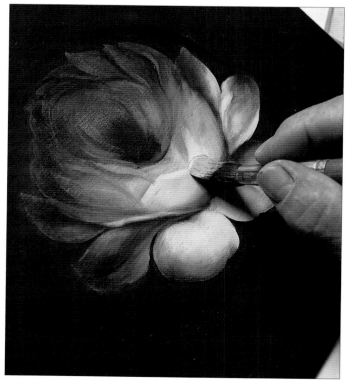

10. Pick up more White on the brush. Form streaks of light color as you fill in the rose. Wipe the brush.

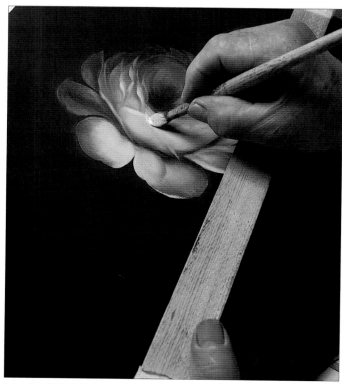

11. Add highlights with Titanium White to form the edges of petals. For the back petals, form edges by adding highlights of Titanium White + Cadmium Red Light (a pink mix).

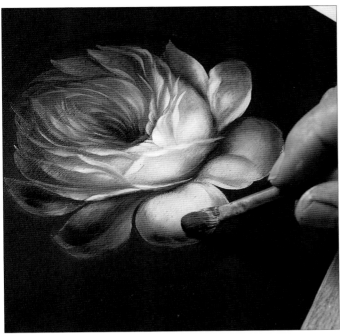

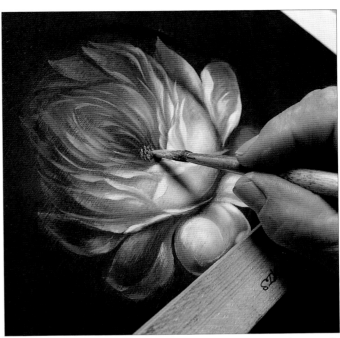

12. If needed, deepen shadow areas with Cadmium Red Deep. Also refine the petals with light mixes, if needed.

13. In the center seed area of the rose, make little dots with Titanium White + Cadmium Yellow Light.

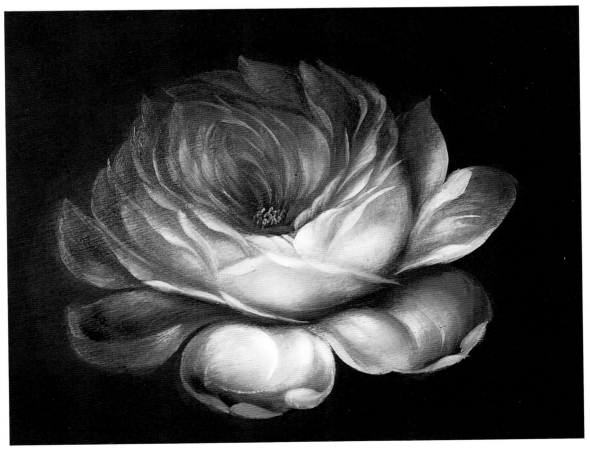

14. The finished rose.

The Projects

Now that you have seen how it is done, you are ready to begin painting some of these lovely designs for yourself. We hope you will find learning this new art form to be exciting and rewarding, as the gorgeous colors mix and blend under your brush.

Look closely at the photos of the finished projects, the painting worksheets, and the step-by-step photos. Read all the instructions and gather your materials before you begin to paint.

Many elements, such as leaves or roses, are repeated in different designs, painted in different colors and sizes. You will be directed to refer to the worksheets and step-by-step photos in "Painting Leaves" or "Painting a Rose" at the beginning of the book, or to the worksheets for other projects. The techniques will be the same; simply use the colors and brush sizes listed in the instructions for the project you are painting.

The distinctive appeal of this Russian folk art painting style comes from the variations of luminous colors in the leaves and flowers. A master painter in Zhostovo will never paint two flower petals or leaves exactly the same, and neither will you! Don't try to produce exact duplicates of the finished projects shown in the photographs. Apply your brush strokes with confidence and let the colors combine as they will-beautifully.

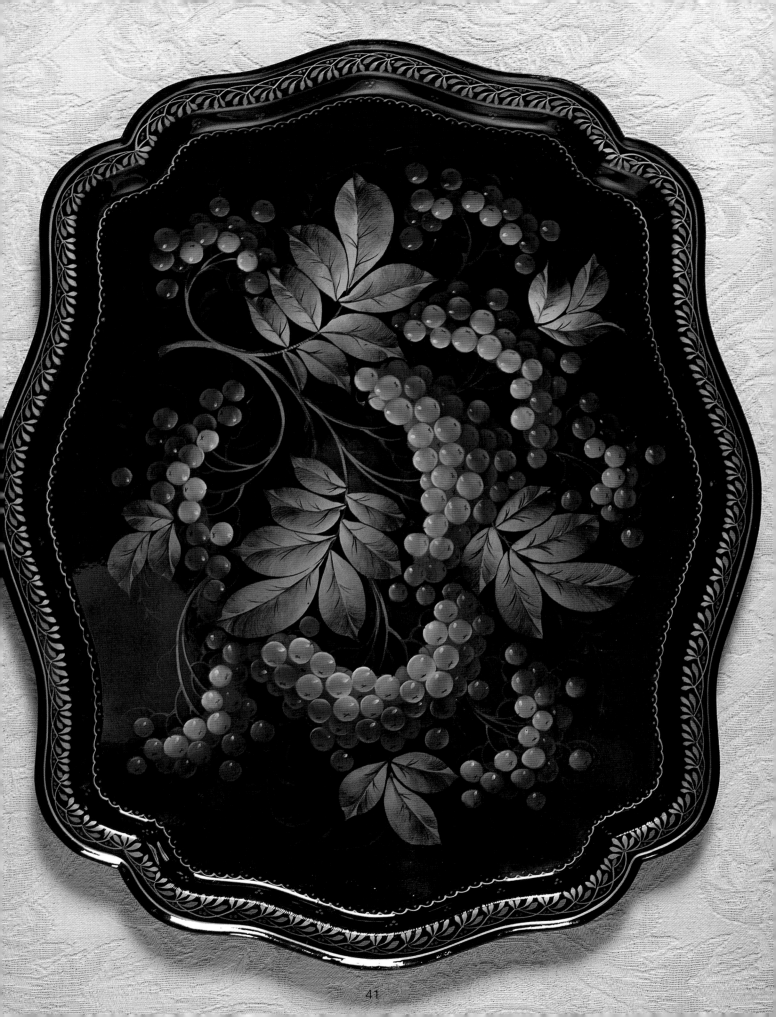

Eternity
ROSE ON OVAL BOX

The red Eternity rose is a perfect theme for a box meant for keepsakes. Its rich colors and touches of gold make this box an elegant accent for any room.

Color worksheets appear on pages 48 & 49.
Pattern appears on page 47.

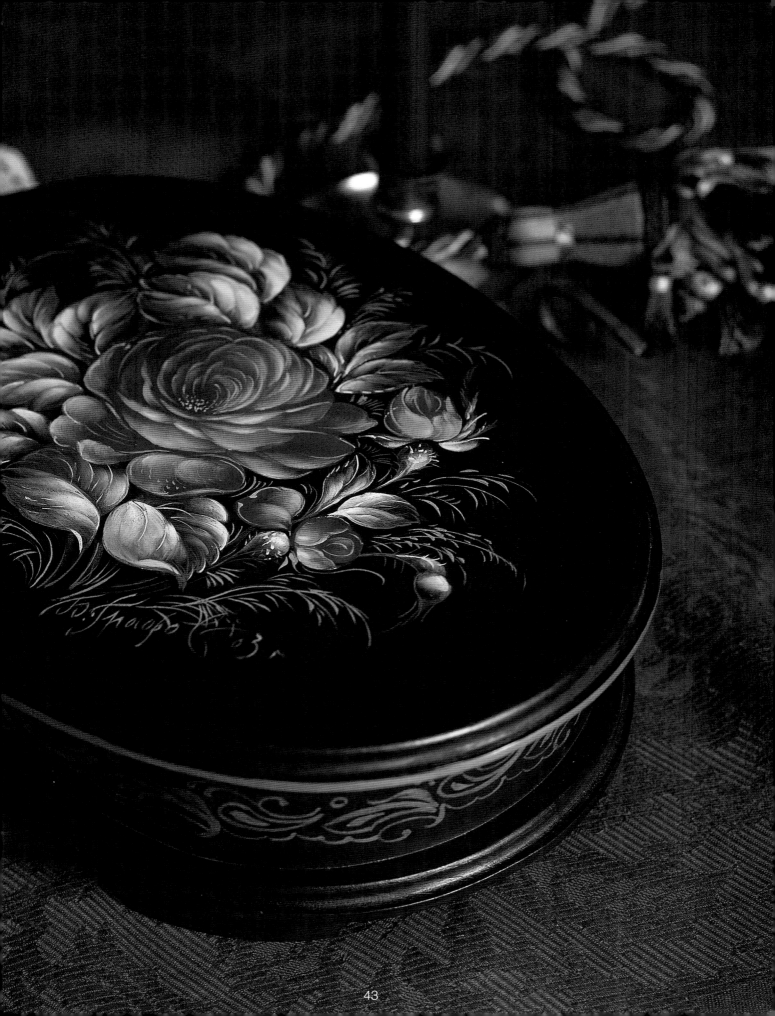

SUPPLIES

Color Palette for Design:
Alizarin Crimson
Cadmium Red Light
Cadmium Red Deep
Cadmium Yellow Medium
Prussian Blue
Sap Green
Viridian
White

Acrylic Craft Paint:
White
Black
Metallic Gold

Brushes:
Filberts
Small (#6)
Medium (#8, #10)
Large (#12)
Liner, #1, #10/0, or scroll brush

Mediums:
Turpenoid
Linseed Oil

Painting Surface:
Oval wooden box

PAINTING INSTRUCTIONS

Preparation:

1. Sand the box. Fill any holes with wood filler, let dry, and sand again. Remove sanding dust with a tack cloth.
2. Basecoat the box by brushing on two coats of black acrylic paint. Let the paint dry and sand after each coat with a crumpled piece of brown paper bag with no printing on it. Wipe off the residue with a tack cloth.
3. Seal with matte acrylic spray, let dry, and rub again with the brown paper bag.
4. Neatly transfer the design, using chalk.

Undercoating:

1. Undercoat the design with white acrylic paint, using the same strokes and direction that you will use to paint the design. Let dry.
2. Gently scrape the entire design with a single-edged razor blade. Hold the razor blade straight up to keep from cutting into the surface. Wipe off any residue.
3. Apply a very thin layer of linseed oil to the undercoating with a small piece of cotton cloth.

Leaves:

Refer to the Basic Leaf Painting Worksheet and step-by-step photos in the "Painting Leaves" section, using colors given here. Paint the leaves with a #8 or #6 filbert brush, depending upon their size.

1. Brush Alizarin Crimson on the tips of the leaves.
2. Brush mix Sap Green + Viridian. Brush over the leaves, allowing some of the Alizarin Crimson to show through. Vary the color of the leaves by using a little more Sap Green on some of the leaves and a little more Viridian on others.
3. Define the vein lines down the centers of the leaves with a brush mix of Viridian + Prussian Blue.
4. With White, use variations of the S-stroke to stroke highlights on the leaves.
5. Thin White to a flowing consistency with linseed oil and turpenoid. Using a liner brush, paint the linework up the centers and on the lightest sides of the leaves.
6. Thin Cadmium Red Light to a flowing consistency with linseed oil and turpenoid. Using a liner brush, paint the linework on some of the leaf tips.
7. Paint calyxes in the leaf colors, using the #6 filbert brush. Apply linework as shown in the photo of the finished project.

Red Eternity Rose:

Refer to the Eternity Rose Painting Worksheet. Use a #12 or #10 filbert brush, depending upon the size you are most comfortable using for the size of the flower. Paint the buds with a #6 filbert brush.

1. Brush Cadmium Red Deep on the tips of the petals and the center of the rose. (See Photo 1.) Wipe the brush; do not clean it.
2. Brush Cadmium Red Light on the remainder of the rose, blending softly and shaping the petals as you stroke. (See Photo 2.) Wipe the brush.
3. Lay in the deep shadows with a brush mix of Alizarin Crimson + Cadmium Red Deep. (See Photo 3.) Wipe the brush.
4. Brush mix Cadmium Red Light + White. Stroke in the front petals using variations of the comma stroke, following the shape of the petals. (See Photo 4.) Wipe the brush.
5. Deepen the shadows with Alizarin Crimson where needed. Wipe the brush.

Continued on page 46

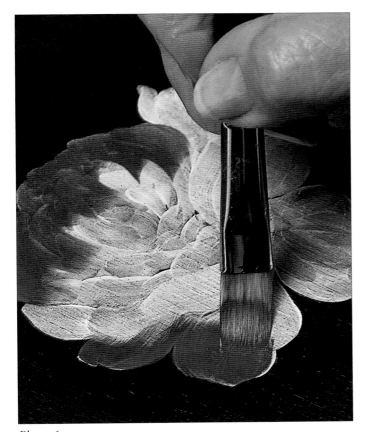

Photo 1

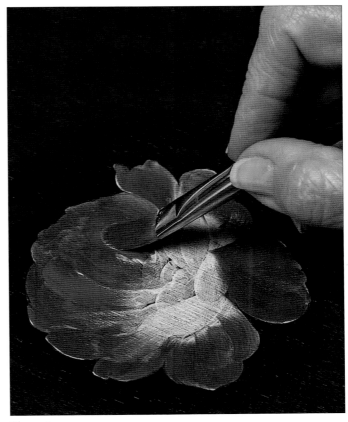

Photo 2

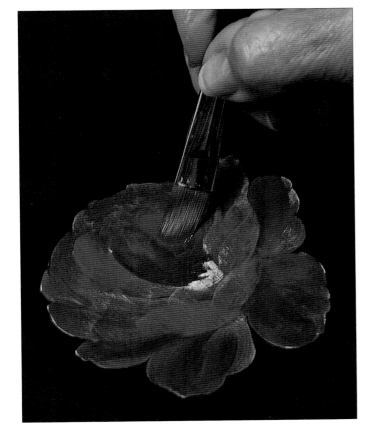

Photo 3

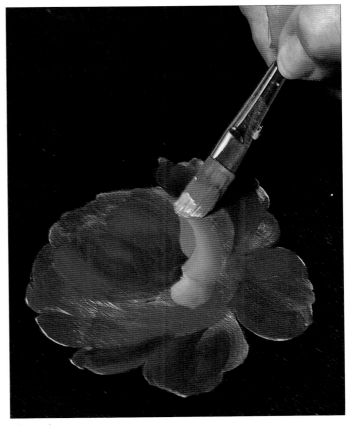

Photo 4

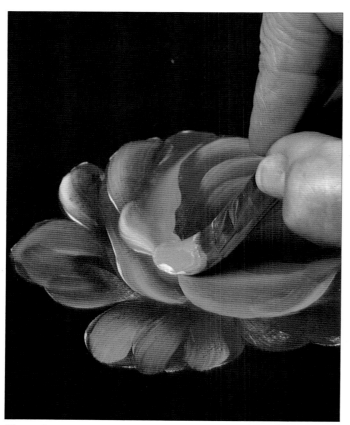

Photo 5

Continued from page 45

6. Stroke White highlights on the front petals and to form the edges of the petals of the rest of the rose. Use variations of the S-stroke and follow the shapes of the petals. (See Photo 5.)

7. Thin White to a flowing consistency with linseed oil and turpenoid. Using the #1 liner brush, paint linework on the edges of petals where needed. (See Photo 6.)

8. Use the #1 liner brush to place dots of Cadmium Yellow Medium in the center of the rose. (See Photo 7.)

9. Paint the rosebuds in the petal colors, using a #6 filbert brush. Apply linework with the #1 liner brush and thinned White.

Linework, Border & Finishing:

Refer to the Linework Filler Ornamentation Painting Worksheet and the border examples in the "Painting Borders" section.

1. Thin Sap Green to a flowing consistency with linseed oil and turpenoid. Using a #1 liner brush, paint ornamental linework "grasses" to fill in the design. Let dry.

2. Using a #1 liner brush and thinned Metallic Gold, paint a border of your choice around the sides of the oval box. Let all paint dry and cure.

3. Following the directions in the "Varnishing" section, apply a glossy finish to the box. ❑

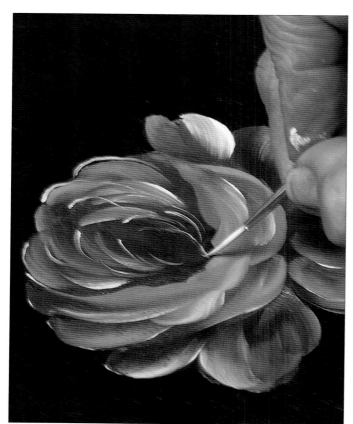

Photo 6

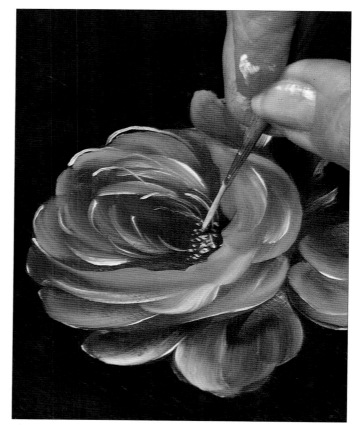

Photo 7

Pattern for Eternity Rose Oval Box
Actual Size

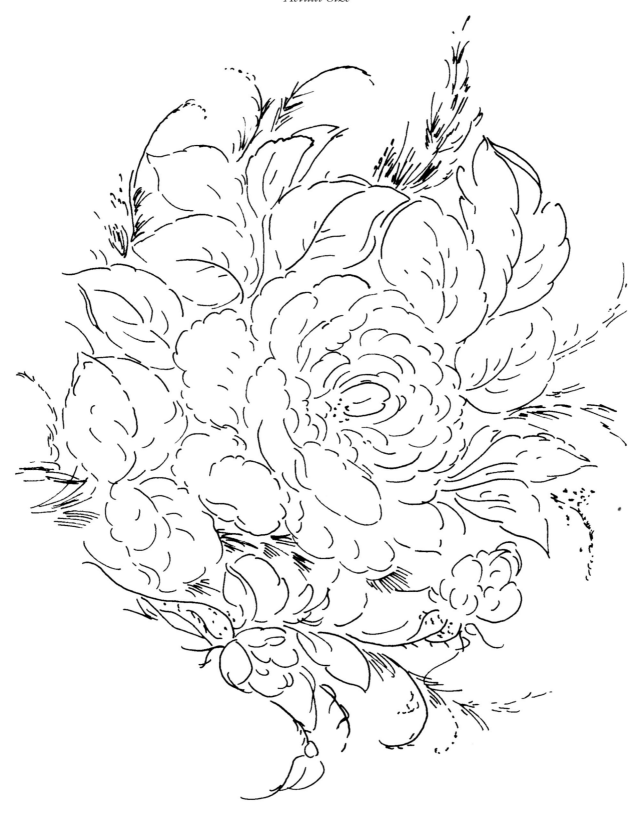

Rose Painting Worksheet

Illustration A
Undercoat with
White acrylic paint.
Let dry.

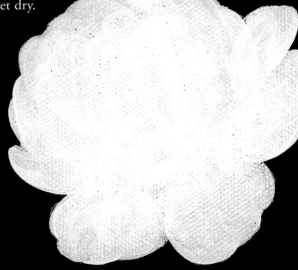

Illustration B
Brush Cadmium Red Deep on the tips
of petals and center of the rose.

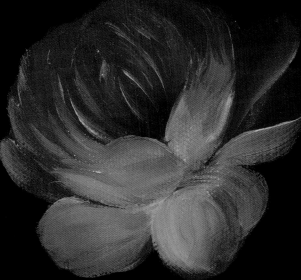

Illustration C
Brush Cadmium Red Light on remaining petals.
Lay in shadows with a brush mix of Alizarin
Crimson + Cadmium Red Deep.

Illustration D
Stroke front petals with a brush mix
of Cadmium Red Light + White.

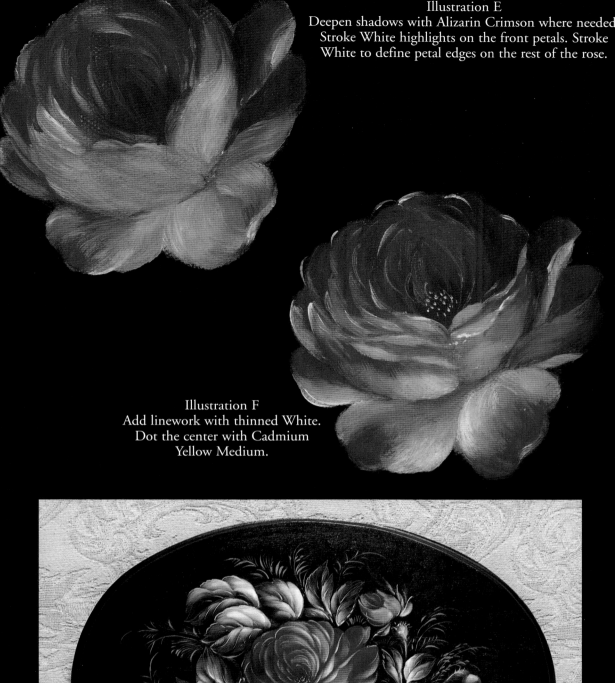

Illustration E
Deepen shadows with Alizarin Crimson where needed.
Stroke White highlights on the front petals. Stroke
White to define petal edges on the rest of the rose.

Illustration F
Add linework with thinned White.
Dot the center with Cadmium
Yellow Medium.

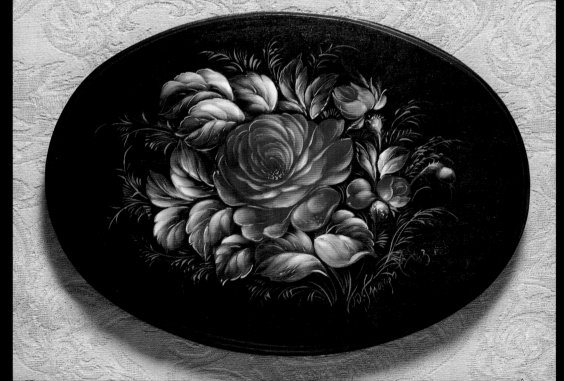

From Boris with Love

BOOK BOX

Zhostovo master painter Boris Grafov created the subtle color variations that give this arrangement of gold-toned roses its depth and serenity.

Color worksheets appear on pages 54 & 55.
Pattern appears on page 56.

SUPPLIES

Color Palette for Design:
Burnt Sienna
Cadmium Yellow Light
Cadmium Yellow Medium
Cadmium Yellow Deep
Cadmium Orange
Sap Green
White

Acrylic Craft Paint:
White
Black
Metallic Gold

Brushes:
Filberts
Small (#4, #6)
Medium (#8)
Large (#12)
Liner (#1, #10/0) or scroll brush

Mediums:
Turpenoid
Linseed Oil

Painting Surface:
Wooden book box

PAINTING INSTRUCTIONS

Preparation:
1. Sand the box. Fill any holes with wood filler, let dry, and sand again. Remove sanding dust with a tack cloth.
2. Basecoat the box by brushing on two coats of black acrylic paint. Let the paint dry and sand after each coat with a crumpled piece of brown paper bag with no printing on it. Wipe off the residue with a tack cloth.
3. Seal with matte acrylic spray, let dry, and rub again with the brown paper bag.
4. Neatly transfer the design, using chalk.

Undercoating:
1. Undercoat the design with white acrylic paint, using the same strokes and direction that you will use to paint the design. Let dry.
2. Gently scrape the entire design with a single-edged razor blade. Hold the razor blade straight up to keep from cutting into the surface. Wipe off any residue.
3. Apply a very thin layer of linseed oil to the undercoating with a small piece of cotton cloth.

Leaves:
Refer to the Basic Leaf Painting Worksheet and step-by-step photos in the "Painting Leaves" section, using colors given here. Paint the leaves with a #8 or #6 filbert brush, depending upon their size.
1. Brush Burnt Sienna on the tips of the leaves.
2. Brush Cadmium Yellow Medium on the leaves, blending softly where the colors meet.
3. Brush Sap Green over the leaves, allowing some of the colors beneath to show through. Vary the color of the leaves by using a little more Sap Green in some areas than in other areas.

4. Define the vein lines down the centers of the leaves with Sap Green. Vary the intensity of the center vein area.
5. With White, use variations of the S-stroke to stroke highlights on the leaves.
6. Thin White to a flowing consistency with linseed oil and turpenoid. Using a #10/0 liner brush, paint the linework up the centers and on the edges of the leaves.
7. Thin Cadmium Orange to a flowing consistency with linseed oil and turpenoid. Using a #10/0 liner brush, paint the linework on some of the leaf tips and edges as shown in the photo of the finished project.
8. Paint the calyxes and stems in the leaf colors, using a #4 filbert brush. Apply linework as shown.

Yellow Rose:
Refer to the Yellow Rose Painting Worksheet. Paint the large rose with a #12 filbert brush. Use a #8 or #6 filbert brush for the smaller roses, depending upon the size you are most comfortable using for the size of the flower.
1. Brush Cadmium Yellow Deep on the tips of the petals and the center of the rose. (See Photo 1.)
2. Brush Cadmium Yellow Medium next, as shown on the Painting Worksheet. Blend softly where the colors meet. (See Photo 2.)
3. Add Cadmium Orange to the tips of a few of the petals and to the center of the rose. (See Photo 3.)
4. Lay in the shadows with Sap Green (see Photo 4) and with Burnt Sienna (see Photo 5). Some of the Burnt Sienna can overlap the Sap Green. Blend softly where the colors meet.

Continued on page 52

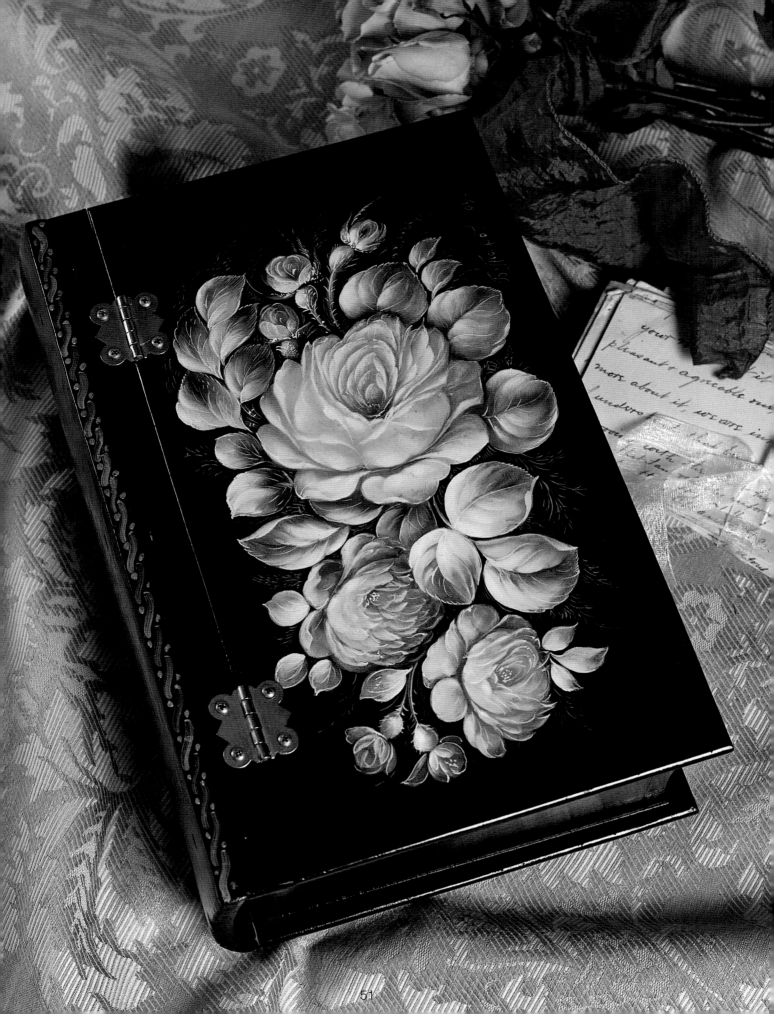

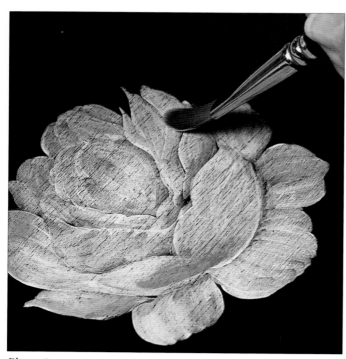

Photo 1

5. Brush mix Cadmium Yellow Light + White. Stroke in the front petals, using variations of the S-stroke and following the shapes of the petals. Stroke the bottom petals using variations of the comma stroke and following the shapes of the petals. (See Photo 6.)

6. Stroke White highlights on the front petals and to define the edges of the petals as needed. Use variations of the S-stroke or comma stroke. (See Photo 7.)

7. Use a #1 liner brush to place dots of White in the center of the rose.

8. Thin White to a flowing consistency with linseed oil and turpenoid. Using a #1 liner brush, paint the linework on the edges of petals.

9. Thin Cadmium Orange to a flowing consistency with linseed oil and turpenoid. Using a #1 liner brush, paint linework on the edges of petals as shown on the Painting Worksheet and the photo of the finished project.

10. Paint the rosebuds in the petal colors, using a #4 or #6 filbert brush. Apply linework as shown.

Linework, Border & Finishing:
Refer to the Linework Filler Ornamentation Painting Worksheet and the border examples in the "Painting Borders" section.

1. Mix White + Cadmium Orange. Thin to a flowing consistency with linseed oil and turpenoid. Using a #10/0 liner brush, paint ornamental linework "grasses" to fill in the design. Let dry.

2. Using a #1 liner brush and thinned Metallic Gold, paint a border of your choice on the "spine" of the book box. Let all paint dry and cure.

3. Following the directions in the "Varnishing" section, apply a glossy finish to the box. ❑

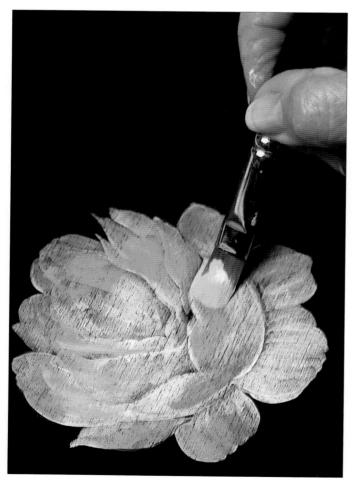

Photo 2

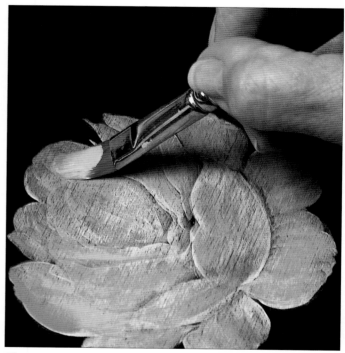

Photo 3

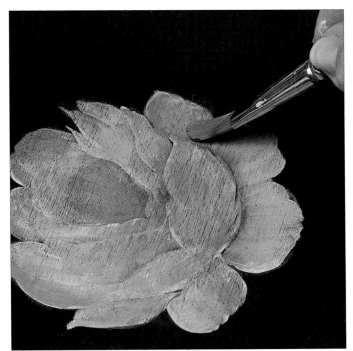

Photo 4

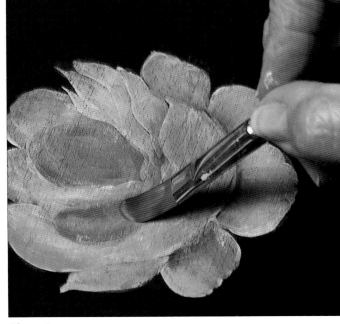

Photo 5

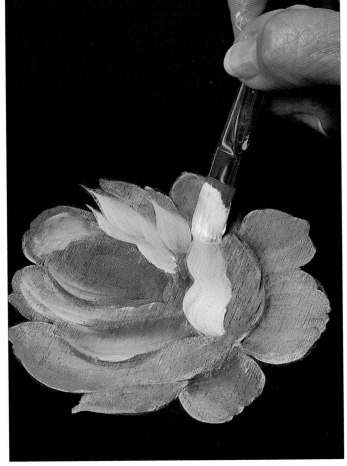

Photo 6

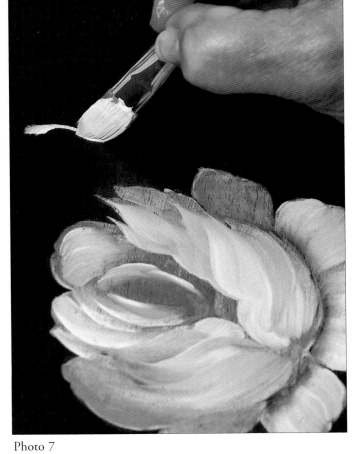

Photo 7

Yellow Rose Painting Worksheet

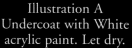

Illustration A
Undercoat with White
acrylic paint. Let dry.

Illustration B
Brush Cadmium Yellow Deep on the tips
of petals and the center of the rose.

Illustration C
Add Cadmium Orange to the tips of the petals.
Lay in shadows with Sap Green and with Burnt Sienna.

Brush on Cadmium Yellow Medium
and softly blend colors.

Illustration D
Stroke in petals with a brush mix of
Cadmium Yellow Light + White.

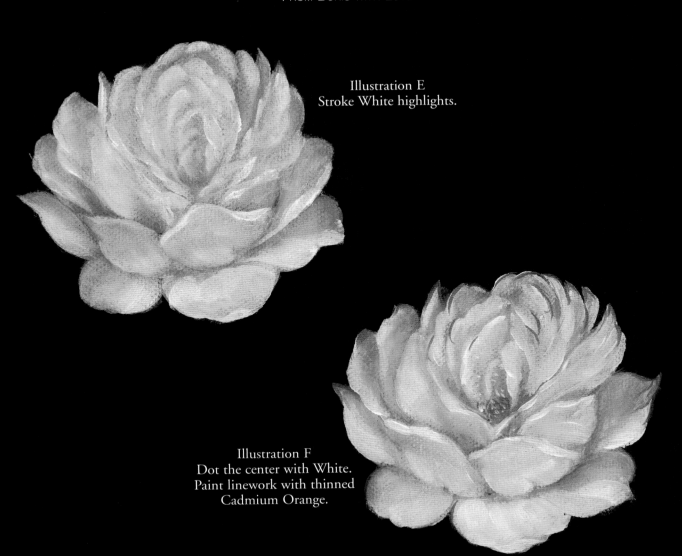

Illustration E
Stroke White highlights.

Illustration F
Dot the center with White.
Paint linework with thinned
Cadmium Orange.

Pattern for From Boris
with Love Book Box
Actual Size

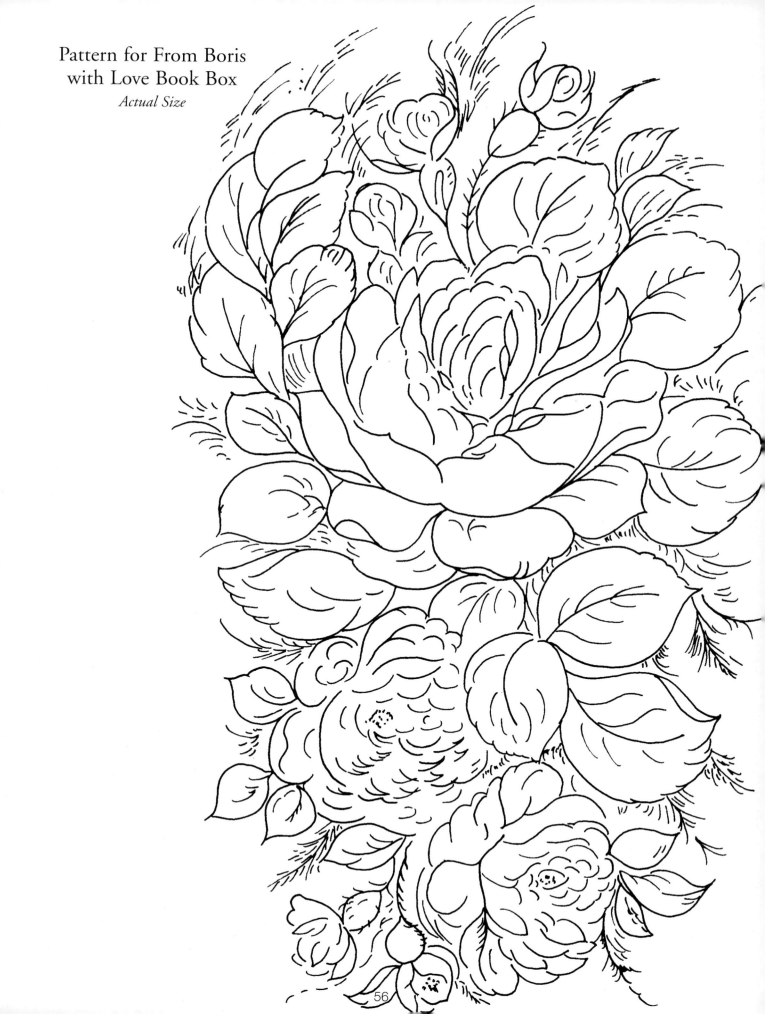

56

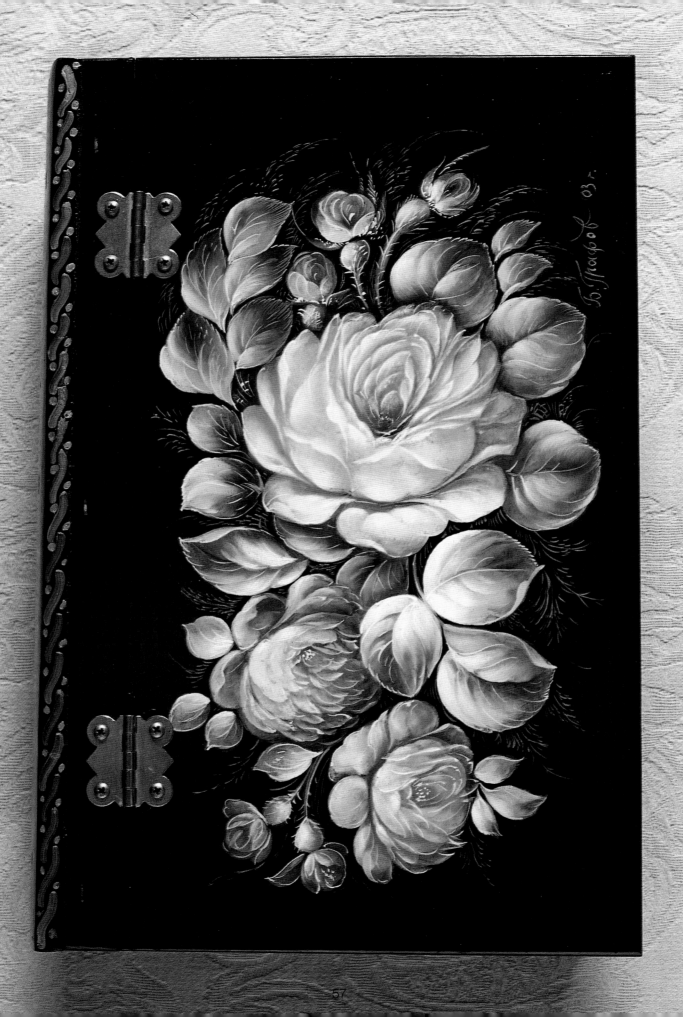

Majestic Magic
ROUND WOODEN TRAY

The exciting colors of this tray will make it the focal point of any room where it is displayed. The unusual gold and silver border forms a stunning frame for the lush rose and chrysanthemum bouquet.

Color worksheet appears on page 62.
Pattern appears on pages 64 & 65.

SUPPLIES

Color Palette for Design:
Alizarin Crimson
Asphaltum
Cadmium Orange
Cadmium Red Light
Cadmium Red Medium
Cadmium Red Deep
Cadmium Yellow Light
Cadmium Yellow Deep
Prussian Blue
Sap Green
Viridian
White

Acrylic Craft Paint:
White
Black
Metallic Gold
Metallic Silver

Brushes:
Filberts
Small (#2, #4, #6)
Medium (#8, #10)
Large (#12)
Liner (#1, #10/0) or scroll brush

Mediums:
Turpenoid
Linseed Oil

Painting Surface:
Round wooden tray

PAINTING INSTRUCTIONS

Preparation:
1. Sand the tray. Fill any holes with wood filler, let dry, and sand again. Remove sanding dust with a tack cloth.
2. Basecoat the tray by brushing on two coats of black acrylic paint. Let the paint dry and sand after each coat with a crumpled piece of brown paper bag with no printing on it. Wipe off the residue with a tack cloth.
3. Seal with matte acrylic spray, let dry, and rub again with the brown paper bag.
4. Neatly transfer the design, using chalk.

Undercoating:
1. Undercoat the design with white acrylic paint, using the same strokes and direction that you will use to paint the design. Let dry.
2. Gently scrape the entire design with a single-edged razor blade. Hold the razor blade straight up to keep from cutting into the surface. Wipe off any residue.
3. Apply a very thin layer of linseed oil to the undercoating with a small piece of cotton cloth.

Green Leaves:
Refer to the Basic Leaf Painting Worksheet and step-by-step photos in the "Painting Leaves" section, using colors given here. Paint the leaves with a #10 or #6 filbert brush, depending upon their size.

Continued on page 60

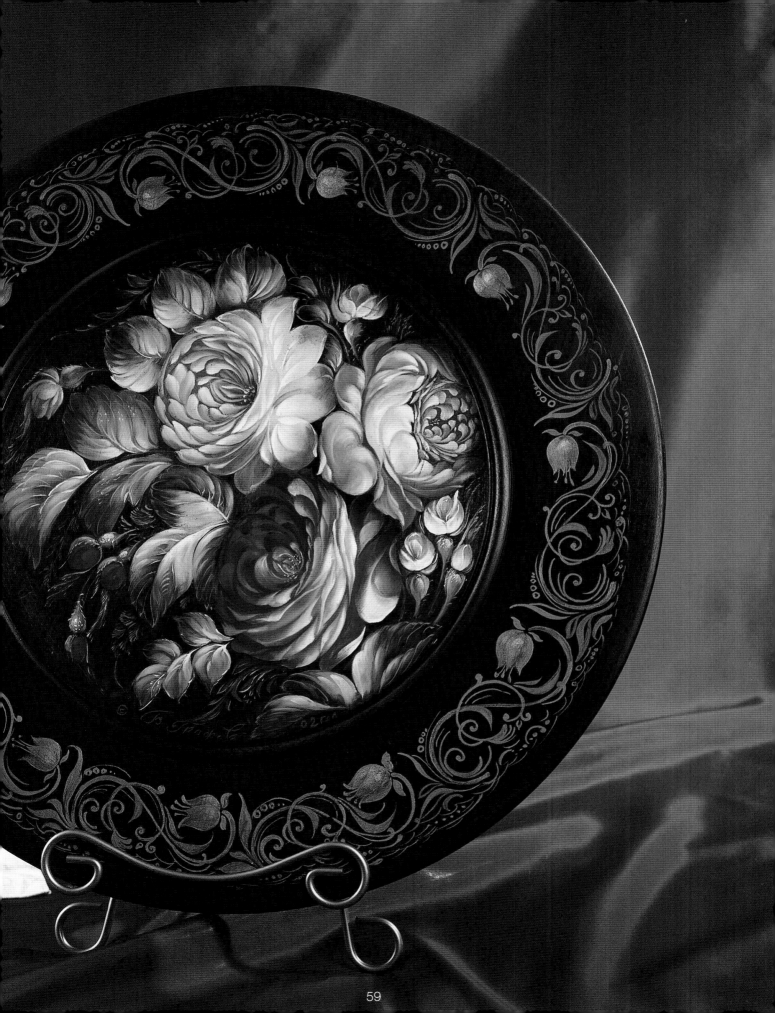

Continued from page 58

1. Brush Alizarin Crimson on the tips of the leaves.
2. Brush mix Sap Green + Viridian. Brush on the leaves, blending softly where the colors meet. Vary the colors of the leaves by using a little more Sap Green on some leaves and a little more Viridian on others. Refer to the photo of the finished project for color variations that indicate turned leaves.
3. Define the vein lines down the centers of the leaves with a brush mix of Sap Green + Viridian.
4. Brush mix White + a touch of Prussian Blue on the palette to make an ice blue. Stroke over the bottom thirds of the leaves, using variations of the S-stroke.
5. With White, use variations of the S-stroke to stroke highlights on the leaves.
6. Thin the ice blue mix to a flowing consistency with linseed oil and turpenoid. Using a liner brush, paint the linework on the centers, veins, and edges of the leaves.
7. Paint calyxes in the leaf colors with a #6 filbert brush. Apply linework as shown.

Fall Leaves:

Refer to the Basic Leaf Painting Worksheet and step-by-step photos in the "Painting Leaves" section, using colors given here. Paint the leaves with a #10 or #6 filbert brush, depending upon their size.

1. Brush mix Cadmium Red Light + Asphaltum. Stroke on the tips of the leaves.
2. Brush Cadmium Yellow Deep next, blending softly where the colors meet.
3. Brush Cadmium Orange on one side of each leaf.
4. Define the vein lines down the centers of the leaves with Cadmium Red Light.

5. Stroke highlights with White. Use variations of the S-stroke and follow the direction of the growth of the leaf.
6. Thin White to a flowing consistency with linseed oil and turpenoid. Using a liner brush, paint the linework as shown in the photo of the finished project.

Red Rose:

Refer to the Rose Painting Worksheet in the "Eternity" project and the "Painting a Rose" step-by-step photos in the "Basic Information" section, using colors given here. Use a number #12 or #10 filbert brush, depending upon the size you are most comfortable using for the size of the petals. Paint the rosebuds with a #8 or #6 filbert brush.

1. Brush Cadmium Red Deep on the tips of the petals and the center of the rose.
2. Brush Cadmium Red Medium on the remainder of the rose, blending softly and shaping the petals as you stroke.
3. With Alizarin Crimson, deepen the center of the rose and lay in the shadows of the petals.
4. Pick up White on the dirty brush. Stroke in the front petals, using S-stroke and comma stroke variations.
5. Stroke Cadmium Orange highlights on the center petals of the rose.
6. Stroke White highlights on the front petals.
7. Thin White to a flowing consistency with linseed oil and turpenoid. Use a liner brush to place dots and paint linework in the center of the rose, as shown in the photo of the finished project.
8. Paint the red rosebuds in the petal colors, using a #6 or #8 filbert brush.

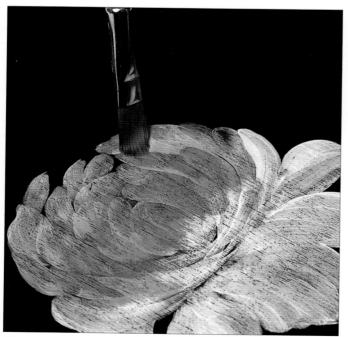

Photo 1

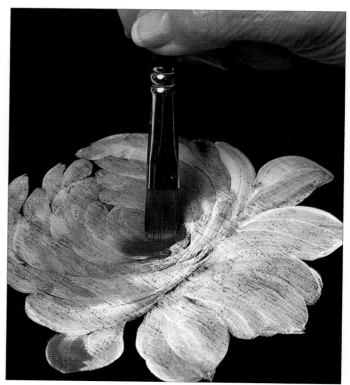

Photo 2

White Chrysanthemum:

Refer to the White Chrysanthemum Painting Worksheet. Paint the larger petals with a #12 filbert brush. Paint the small petals with a #8 filbert brush.

1. Using the #12 filbert brush, apply a brush mix of Sap Green + Viridian on the top of the flower and on two of the lower petals.
2. Add Cadmium Yellow Deep next. Blend softly where the colors meet. (See Photo 1.)
3. Lay in the center color of the flower with Cadmium Red Deep. (See Photo 2.)
4. With Cadmium Red Medium, stroke color on the left, as if reflecting the color of the red rose next to it. (See Photo 3.) Wipe the brush.
5. Brush mix White + a touch of Prussian Blue on the palette to make an ice blue. Apply the front petals and lower right petals. (See Photo 4.)
6. Use the #8 filbert brush to define the small petals with White comma strokes. (See Photo 5.)
7. Use the #12 filbert brush to add White highlights on the front petals and lower right petals.
8. Thin White to a flowing consistency with linseed oil and turpenoid. Use a #1 liner brush to place dots and paint linework in the center of the flower.
9. Paint the buds with a #6 or #8 filbert brush. Use the ice blue petal colors for the bud on the right, and the fall leaf colors for the bud on the left. Highlight the bud petals with White.

Yellow Chrysanthemum :

Refer to the White Chrysanthemum Painting Worksheet, using colors given here. Use a #12 filbert brush for the larger petals, and smaller brushes for the smaller petals.

1. Using a #12 filbert brush, brush the tips of the petals and the sides of the bowl of the flower with Cadmium Red Deep.
2. Brush mix Sap Green + Viridian. Lay in the center of the flower.

Continued on page 64

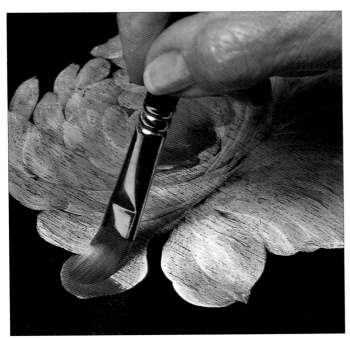

Photo 3

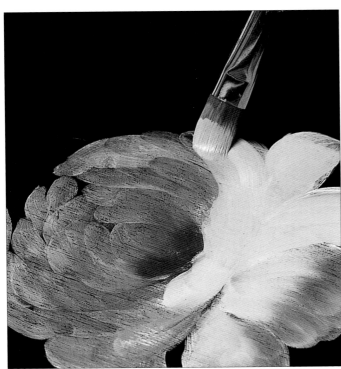

Photo 4

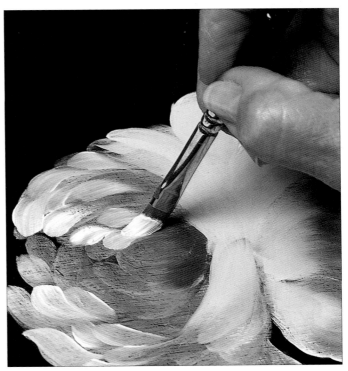

Photo 5

White Chrysanthemum Painting Worksheet

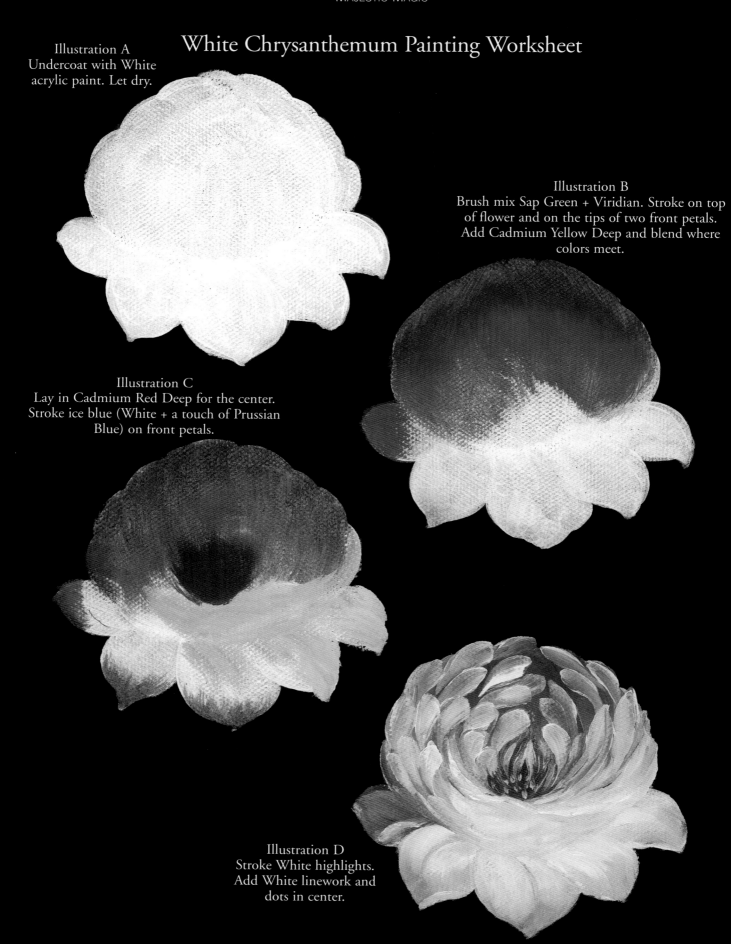

Illustration A
Undercoat with White acrylic paint. Let dry.

Illustration B
Brush mix Sap Green + Viridian. Stroke on top of flower and on the tips of two front petals. Add Cadmium Yellow Deep and blend where colors meet.

Illustration C
Lay in Cadmium Red Deep for the center. Stroke ice blue (White + a touch of Prussian Blue) on front petals.

Illustration D
Stroke White highlights. Add White linework and dots in center.

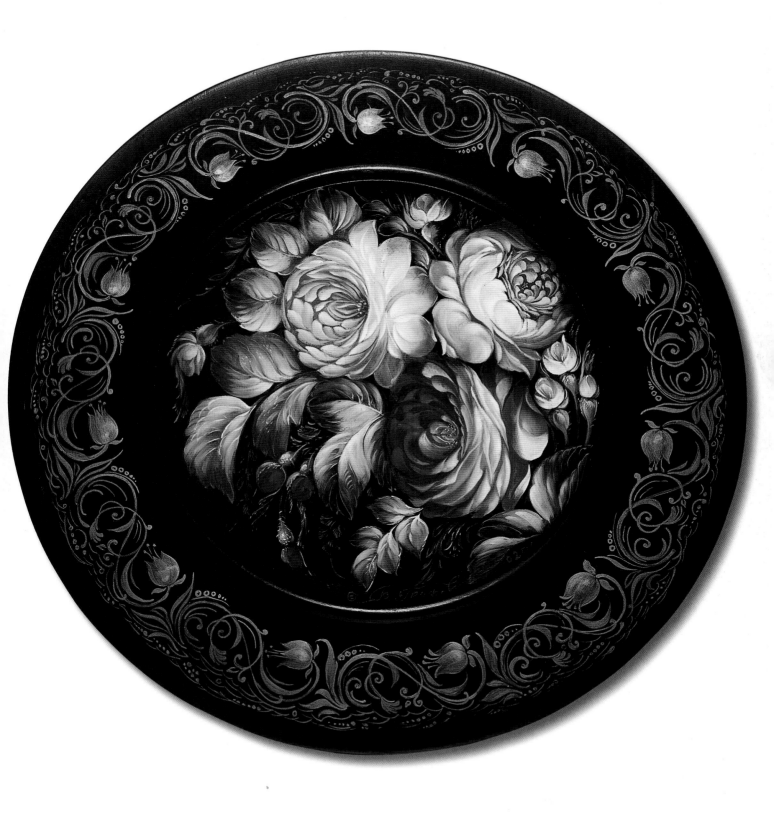

continued from page 61

3. Shade the lower edge of the center with Asphaltum.

4. Lay in the front petals with Cadmium Yellow Light.

5. Highlight with White to define the shapes of the front petals and the petals forming the bowl of the flower.

6. With White, apply comma strokes to define the small petals inside the bowl of the flower. Use a #8 or #10 filbert brush for the larger center petals and a #2 or #4 filbert brush for the smaller center petals.

7. Thin White to a flowing consistency with linseed oil and turpenoid. Use a #1 liner brush to place dots in the center of the flower.

8. Paint the buds in pale leaf colors, using a #8 or #6 filbert brush. On the bud petal nearest the red rose, stroke a little Cadmium Red Deep to reflect the rose color.

Linework, Border & Finishing:
Refer to the Linework Filler Ornamentation Painting Worksheet and the border examples in the "Painting Borders" section.

1. Using a #10/0 liner brush with thinned ice blue (White + a touch of Prussian Blue), thinned Sap Green, and thinned Cadmium Red Medium, paint ornamental linework "grasses" to fill in the design. Let dry.

2. Paint the tulip border with thinned Metallic Gold. Use a #6 filbert brush for the tulips and a #4 or #6 filbert brush for the tulip leaves. Use a #1 liner brush for the remaining border strokes. Let dry.

3. Thin Metallic Silver to a flowing consistency with linseed oil and turpenoid. Brush highlights on the border tulips with a #4 or #6 filbert brush. Let all paint dry and cure.

4. Following the directions in the "Varnishing" section, apply a glossy finish to the tray. ❏

Pattern for Majestic Magic Tray
Enlarge pattern @160% for actual size.

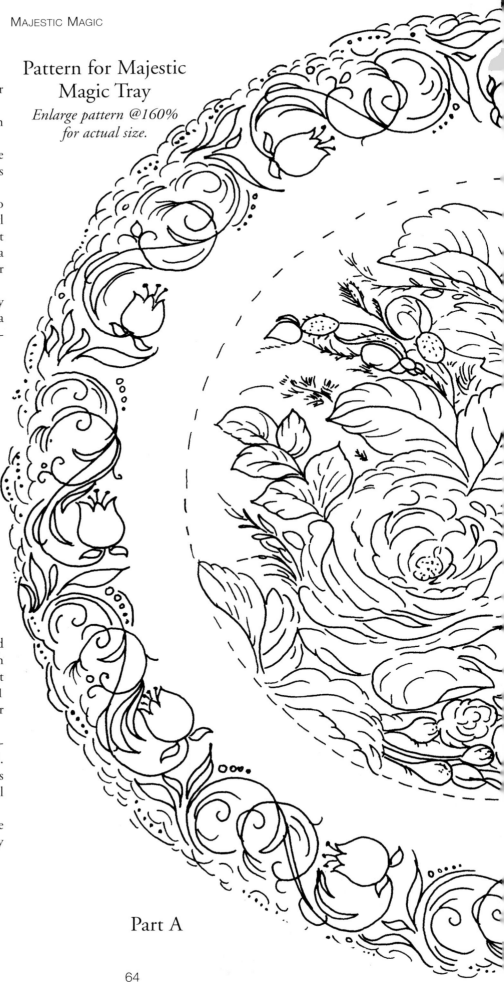

Part A

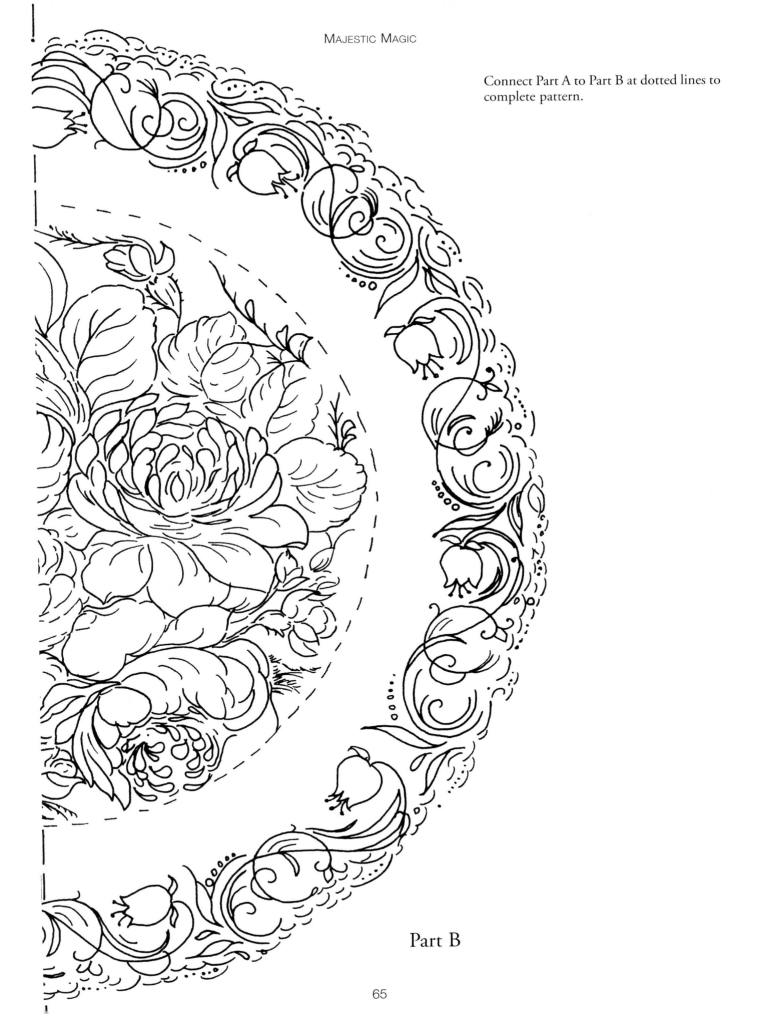

Connect Part A to Part B at dotted lines to
complete pattern.

Part B

Time For Tulips
WOODEN CLOCK

The fresh spring colors of this tulip brighten every hour when you display this cheerful timekeeper. The graceful composition of the leaves, open tulip, and bud emphasizes the vertical shape of the clock.

Color worksheet appears on page 70.

SUPPLIES

Color Palette for Design:
Alizarin Crimson
Cadmium Red Deep
Cadmium Yellow Light
Prussian Blue
Sap Green
Viridian
White

Acrylic Craft Paint:
White
Black
Metallic Gold

Brushes:
Filberts
Medium (#10)
Large (#12)
Liner (#1, #10/0) or scroll brush

Mediums:
Turpenoid
Linseed Oil

Painting Surface:
Wooden clock

PAINTING INSTRUCTIONS

Preparation:
1. Remove the clock works and sand the clock. Fill any holes with wood filler, let dry, and sand again. Remove sanding dust with a tack cloth.
2. Basecoat the clock by brushing on two coats of black acrylic paint. Let the paint dry and sand after each coat with a crumpled piece of brown paper bag with no printing on it. Wipe off the residue with a tack cloth.
3. Seal with matte acrylic spray, let dry, and rub again with the brown paper bag.
4. Neatly transfer the design, using chalk.

Undercoating:
1. Undercoat the design with white acrylic paint, using the same strokes and direction that you will use to paint the design. Let dry.
2. Gently scrape the entire design with a single-edged razor blade. Hold the razor blade straight up to keep from cutting into the surface. Wipe off any residue.
3. Apply a very thin layer of linseed oil to the undercoating with a small piece of cotton cloth.

Tulip Leaves:
Refer to the Blade Leaf Painting Worksheet in the "Painting Leaves" section, using colors given here. Paint the tulip leaves with a #10 filbert brush.
1. Brush Cadmium Red Deep on the tips and at the base of the leaves. (See Photo 1.)
2. Brush mix Sap Green + Viridian. Brush on the center areas of the leaves, blending softly where the colors meet. (See Photo 1.)
3. Define the deepest shaded areas of the leaf with a brush mix of Viridian + Prussian Blue. (See Photo 2.)
4. Stroke highlights with White, using variations of the S-stroke and following the natural curve of the leaves. (See Photo 3.)
5. Thin White to a flowing consistency with linseed oil and turpenoid. Using the #1 liner brush, paint the linework. (See Photo 4.)

Continued on page 68

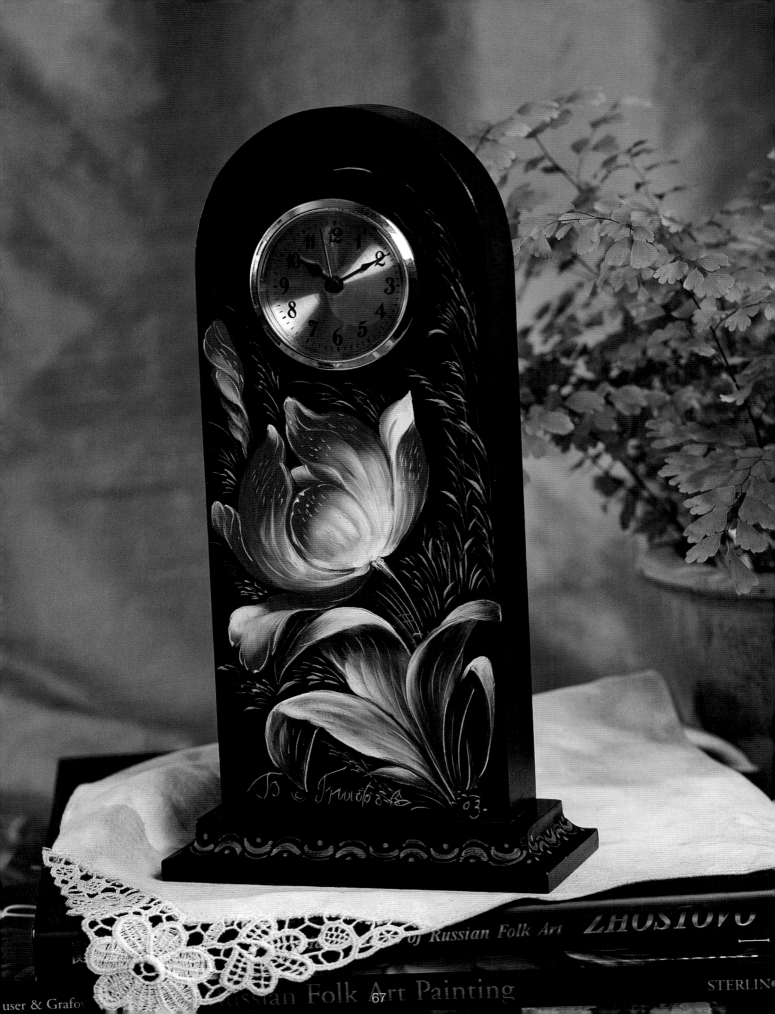

continued from page 66

Tulips:

Refer to the Tulip Painting Worksheet. Use the #12 or #10 filbert brush, depending upon the size you are most comfortable using for the size of the flower.

1. Brush Cadmium Red Deep on the tips of the petals and at the base of the tulip. (See Photo 5.)
2. Brush Cadmium Yellow Light at the bottom of the three center petals. (See Photo 6.)
3. Stroke in the deep shadows with a brush mix of Alizarin Crimson + Cadmium Red Deep, using S-strokes. (See Photo 7.) Wipe the brush on a cloth or paper towel, but do not clean the brush.
4. Softly stroke the highlights with White, shaping the petals as you stroke. (See Photo 8.)
5. Wipe the brush and load more White into the brush. Brush additional White highlights where needed. If necessary, clean the brush before adding the lightest highlights.
6. Thin White to a flowing consistency with linseed oil and turpenoid. Using a #1 liner brush, paint the linework on the petals. (See Photo 9.)
7. Paint the tulip bud with a #10 or #12 filbert brush, using the petal colors. Apply linework as shown in the photo of the finished project.

Linework, Border & Finishing:

Refer to the Linework Filler Ornamentation Painting Worksheet and the border examples in the "Painting Borders" section.

1. Thin Sap Green to a flowing consistency with linseed oil and turpenoid. Using a #10/0 liner brush, paint ornamental linework "grasses" to fill in the design. Let dry.

Photo 2

Photo 3

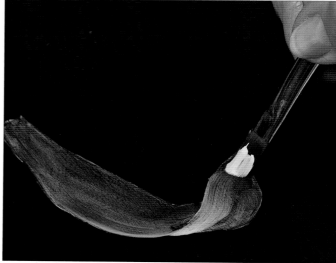

Photo 4

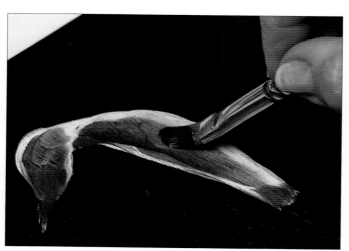

Photo 1

68

2. Using a #1 liner brush and thinned Metallic Gold, paint a border of your choice around the base of the clock. Let all paint dry and cure.

3. Following the directions in the "Varnishing" section, apply a glossy finish to the clock.

4. Assemble the clock works when the varnish is completely dry. ❏

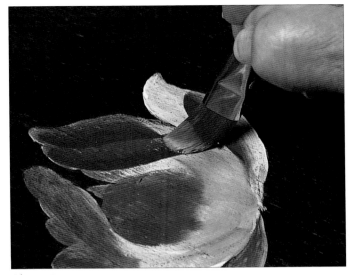

Photo 7

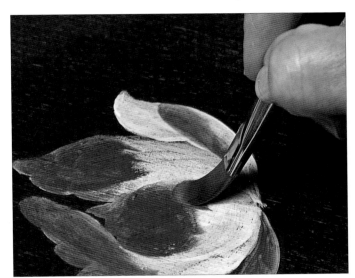

Photo 5

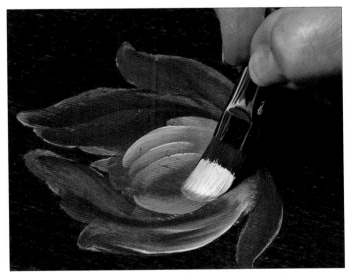

Photo 8

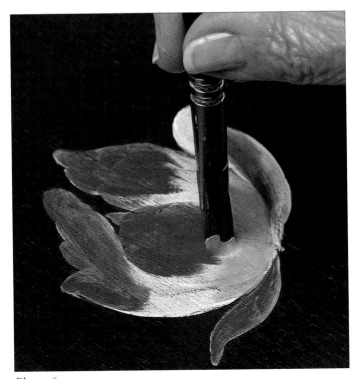

Photo 6

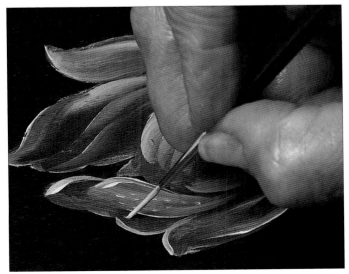

Photo 9

Tulip Painting Worksheet

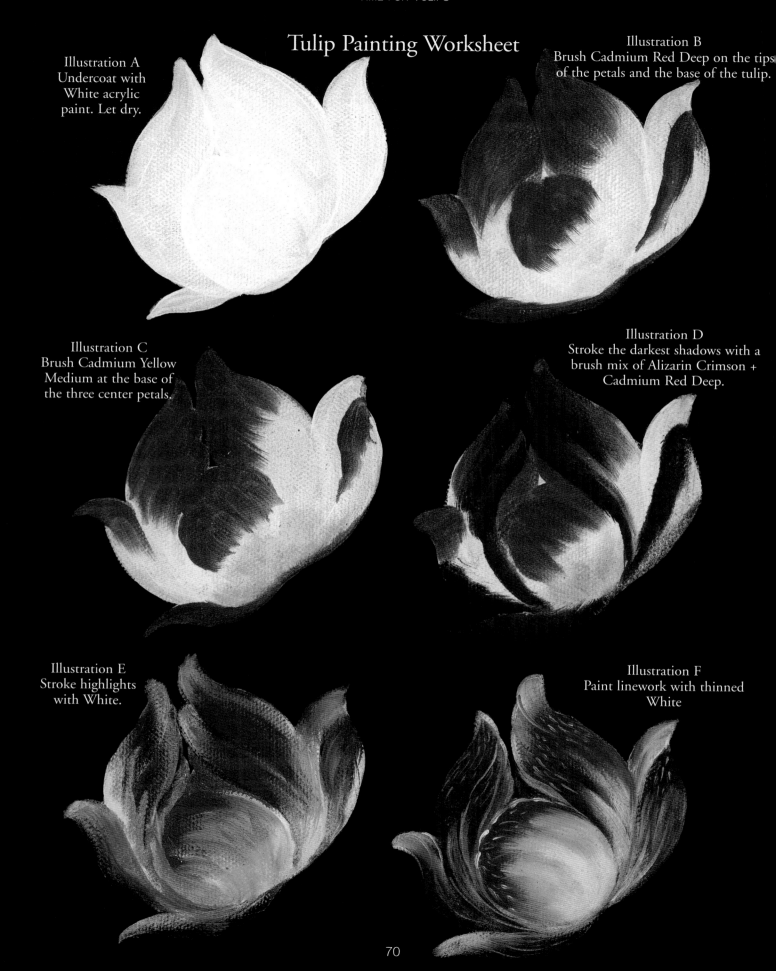

Illustration A
Undercoat with White acrylic paint. Let dry.

Illustration B
Brush Cadmium Red Deep on the tips of the petals and the base of the tulip.

Illustration C
Brush Cadmium Yellow Medium at the base of the three center petals.

Illustration D
Stroke the darkest shadows with a brush mix of Alizarin Crimson + Cadmium Red Deep.

Illustration E
Stroke highlights with White.

Illustration F
Paint linework with thinned White

Pattern for Time for Tulips Clock
Actual Size

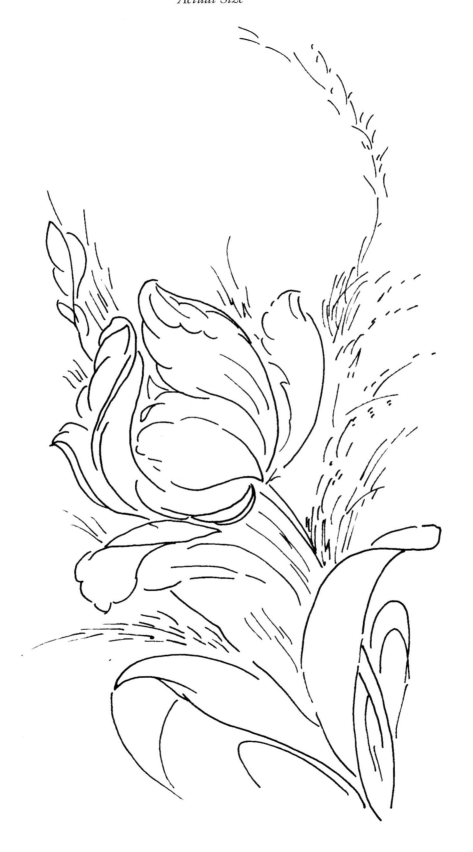

Moon Light
SQUARE WOODEN PLATE

Blossom flowers can be painted in many colors and are often used to fill out a bouquet. As the only flowers in this design, these large, pale blossoms take center stage. Against the black background, they glow as if they were lighted by a full moon.

Color worksheet appears on page 76.
Pattern appears on page 77.

SUPPLIES

Color Palette for Design:
Burnt Sienna
Cadmium Red Light
Cadmium Red Medium
Cadmium Yellow Light
Prussian Blue
Sap Green
Viridian
White

Acrylic Craft Paint:
White
Black
Metallic Gold

Brushes:
Filberts
Small (#2, #4, #6)
Medium (#8, #10)
Large (#12)
Liner (#1) or scroll brush

Mediums:
Turpenoid
Linseed Oil

Painting Surface:
Square, beaded wooden plate

PAINTING INSTRUCTIONS

Preparation:
1. Sand the plate. Fill any holes with wood filler, let dry, and sand again. Remove sanding dust with a tack cloth.
2. Basecoat the plate by brushing on two coats of black acrylic paint. Let the paint dry and sand after each coat with a crumpled piece of brown paper bag with no printing on it. Wipe off the residue with a tack cloth.
3. Seal with matte acrylic spray, let dry, and rub again with the brown paper bag.
4. Neatly transfer the design, using chalk.

Undercoating:
1. Undercoat the design with white acrylic paint, using the same strokes and direction that you will use to paint the design. Let dry.
2. Gently scrape the entire design with a single-edged razor blade. Hold the razor blade straight up to keep from cutting into the surface. Wipe off any residue.
3. Apply a very thin layer of linseed oil to the undercoating with a small piece of cotton cloth.

Leaves:
Refer to the Basic Leaf Painting Worksheet and step-by-step photos in the "Painting Leaves" section, using colors given here. Paint the leaves with a #10 or #8 filbert brush, depending upon their size.

Continued on page 74

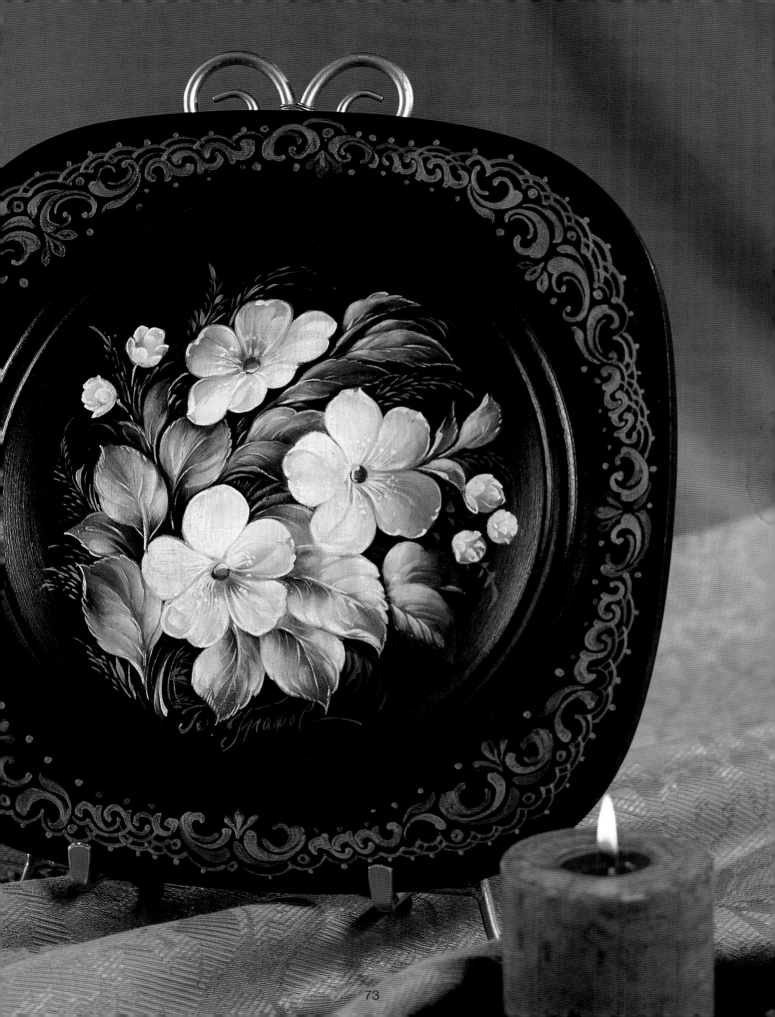

continued from page 72

1. Brush Burnt Sienna on the tips of the leaves.
2. Brush Cadmium Yellow Light next, blending softly where the colors meet.
3. Brush mix Sap Green + Viridian. Brush over the leaves, allowing some of the colors beneath to show through. Vary the colors of the leaves by using a little more Sap Green on some leaves and a little more Viridian on others.
4. Define the vein lines down the centers of the leaves with a brush mix of Viridian + Prussian Blue.
5. With White, use variations of the S-stroke to stroke highlights on the leaves.
6. Thin White to a flowing consistency with linseed oil and turpenoid. Using a #1 liner brush, paint the linework on the veins and the lightest edges of the leaves.
7. Thin Cadmium Red Medium to a flowing consistency with linseed oil and turpenoid. Using a #1 liner brush, paint linework on some of the leaf tips as shown in the photo of the finished project.

Blossoms:
Refer to the Blossom Painting Worksheet. Paint the petals with a #12 filbert brush.

1. Apply Cadmium Yellow Light in the centers of the blossoms, brushing it slightly outward onto the petals. (See Photo 1.)
2. Brush Cadmium Red Light on two of the petals, brushing from the outer tips toward the centers. (See Photo 2.)

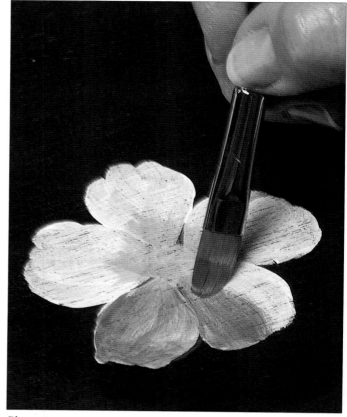

Photo 2

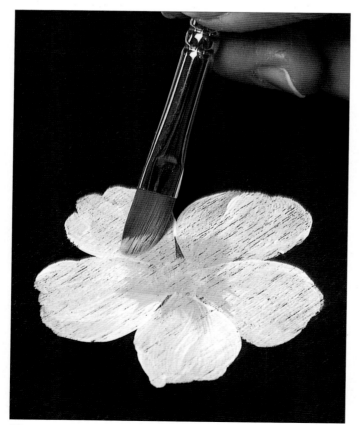

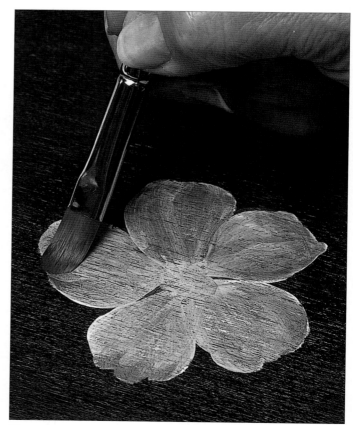

Photo 1

Photo 3

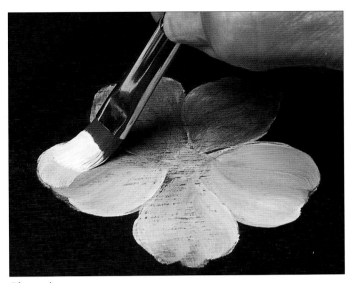

Photo 4

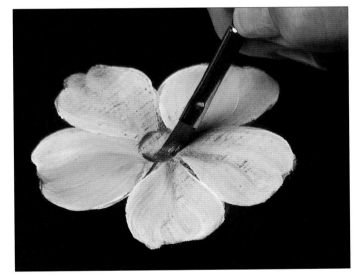

Photo 5

3. Shade the base of each petal with Sap Green. Add a touch of Sap Green to the center of the outer edge of each petal *not* shaded with Cadmium Red Light. (See Photo 3.)

4. Mix White + a touch of Prussian Blue to make an ice blue. Lightly stroke over each petal.

5. Stroke White highlights on the petals. (See Photo 4.)

6. Using a #4 or #6 filbert brush and Burnt Sienna, shade the center with a C-stroke. (See Photo 5.)

7. Thin White to a flowing consistency with linseed oil and turpenoid. Using a #1 liner brush, paint the linework around the petals, and the dots and lines radiating out from the center. (See Photo 6 and 7.)

Linework, Border & Finishing:

Refer to the Linework Filler Ornamentation Painting Worksheet and the border examples in the "Painting Borders" section.

1. Thin Sap Green to a flowing consistency with linseed oil and turpenoid. Thin Raw Sienna to a flowing consistency with linseed oil and turpenoid. Using a #1 liner brush, paint ornamental linework "grasses" to fill in the design. Let dry.

2. Using thinned Metallic Gold, paint the border. Use the #2 or #4 filbert brush to paint the larger scrollwork, and the #1 liner brush to paint the more delicate areas. Dip the handle end of the brush into the paint, then touch to the surface to apply dots. Let all paint dry and cure.

3. Following the directions in the "Varnishing" section, apply a glossy finish to the plate. ❑

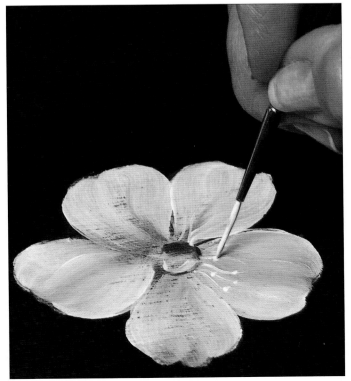

Photo 7

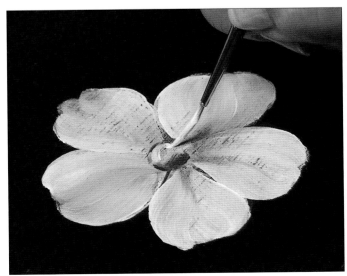

Photo 6

Blossom Painting Worksheet

Illustration A
Undercoat with
White acrylic
paint. Let dry.

Illustration B
Brush Cadmium Yellow Light
in the center.

Illustration C
Brush Cadmium
Red Light on two
petals.

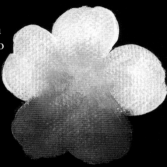

Illustration D
Shade with Sap Green.

Illustration E
Stroke ice blue (White +
a touch of Prussian Blue)
over each petal.

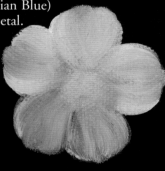

Illustration F
Add White highlights.

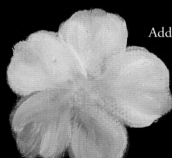

Illustration G
Stroke linework on the
petals with thinned
White.

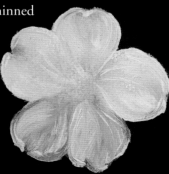

Illustration H
Shade the center with
Burnt Sienna.
Add dots and linework
radiating from the
center with
thinned White.

Pattern for Moon Light Plate

Enlarge pattern @160% for actual size.

Flavors of Fall
METAL TRAY

A harvest of plump berries fills this tray with autumn colors.
The careful application of shadows and highlights makes the ripe
fruit look translucent, juicy and delicious.

Color worksheet appears on page 82.

SUPPLIES

Color Palette for Design:
Asphaltum
Alizarin Crimson
Cadmium Orange
Cadmium Red Light
Cadmium Yellow Medium
Cadmium Yellow Deep
White

Spray Paint:
Flat black

Acrylic Craft Paint:
White
Metallic Gold

Brushes:
Filberts
Small (#4, #6)
Medium (#8)
Liner (#1, #10/0) or scroll brush

Mediums:
Turpenoid
Linseed Oil

Painting Surface:
Primed metal tray

PAINTING INSTRUCTIONS

Preparation:
1. Basecoat the tray by spraying on two or three coats of flat black paint. Let the paint dry and sand after each coat with very soft, fine steel wool. Wipe off all residue with a tack cloth. Sand after the last coat with a crumpled piece of brown paper bag with no printing on it. Wipe with a tack cloth.
2. Seal with matte acrylic spray. Let dry. Rub lightly again with the brown bag. Wipe off residue with the tack cloth.
3. Neatly transfer the design, using chalk.

Undercoating:
1. Undercoat the design with white acrylic paint, using the same strokes and direction that you will use to paint the design. Let dry.
2. Gently scrape the entire design with a single-edged razor blade. Hold the razor blade straight up to keep from cutting into the surface. Wipe off any residue.
3. Rub with the brown paper bag. Remove all residue with the tack cloth.
4. Apply a very thin layer of linseed oil to the undercoating with a small piece of cotton cloth.

Leaves:
Refer to the Berry & Leaves Painting Worksheet. Paint the leaves with a #8 or #6 filbert brush, depending upon their size.
1. Brush Cadmium Yellow Deep on the tips of the leaves.
2. Stroke Metallic Gold over the rest of the leaves, following the direction of growth. Allow some of the Cadmium Yellow Deep to show through.
3. Shade the leaves with Asphaltum.
4. Thin Asphaltum to a flowing consistency with linseed oil and turpenoid. Using the #10/0 liner brush, paint the veins and linework on the leaves.

Berries:
Refer to the Berry & Leaves Painting Worksheet. Paint the berries with a #8 or #6 filbert brush, depending upon the size you are most comfortable using for the size of the berries.
1. Brush Cadmium Red Light on the cluster of berries, covering the cluster entirely. (See Photo 1.)

Continued on page 80

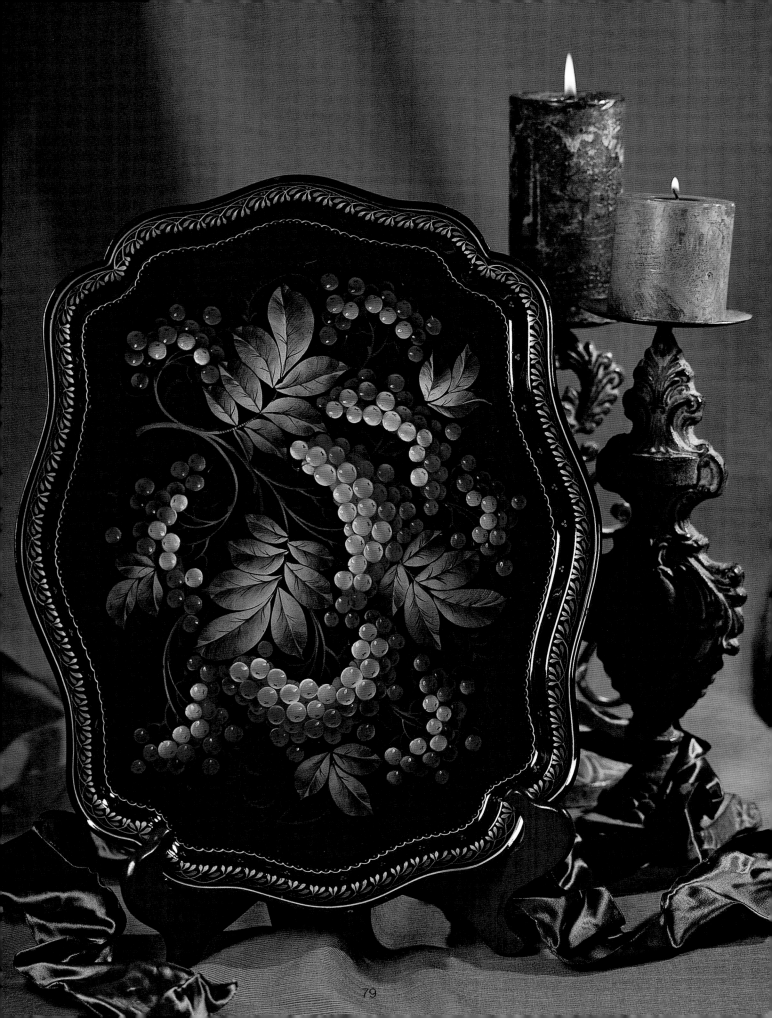

continued from page 78

2. Using the same brush, apply Alizarin Crimson on the berries in the rear. Softly blend the colors and shape the berries as you stroke. (See Photo 2.)

3. Stroke Cadmium Yellow Deep on the tops of the berries in front. (See Photo 3.)

4. Brush Cadmium Orange on the bottoms of the berries in front, blending softly with the Cadmium Yellow Deep. (See Photo 4.)

5. Highlight the berries with a stroke of Cadmium Yellow Medium in the center bottom of the berries in front. (See Photo 5.)

6. Using a #4 filbert brush, add White highlights on some of the berries. Brush C-strokes to follow the curves of the berries. (See Photo 6.)

7. Thin Asphaltum to a flowing consistency with linseed oil and turpenoid. Using the #10/0 liner brush, stroke the details to define the blossom end of each berry. (See Photo 7.)

Linework, Border & Finishing:
Refer to the Linework Filler Ornamentation Painting Worksheet and the border examples in the "Painting Borders" section.

1. Thin Cadmium Red Medium to a flowing consistency with linseed oil and turpenoid. Using a #1 liner brush, paint ornamental linework "grasses" to fill in the design. Let dry.

2. Paint the borders with thinned Metallic Gold. Use a #1 liner for the border along the ridge of the tray. Use a #10/0 liner for the border inside the ridge. Dip the handle end of the brush into the paint, then touch to the surface to apply dots. Let all paint dry and cure.

3. Following the directions in the "Varnishing" section, apply a glossy finish to the tray. ❑

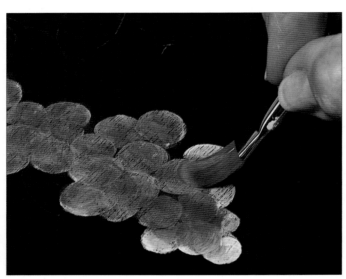

Photo 1

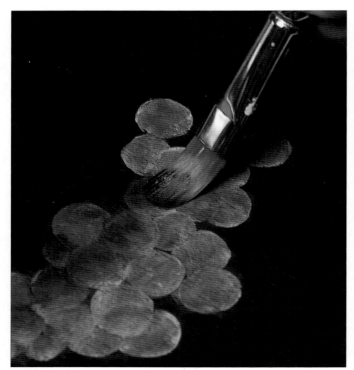

Photo 2

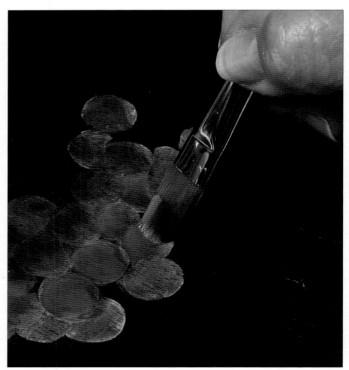

Photo 3

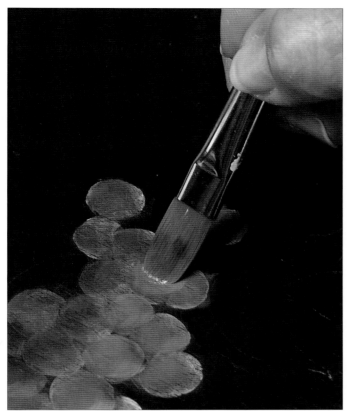

Photo 4

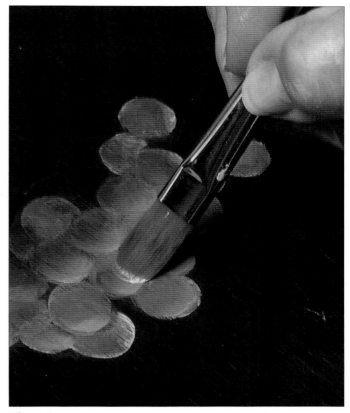

Photo 5

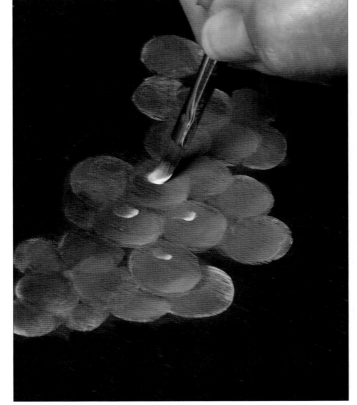

Photo 6

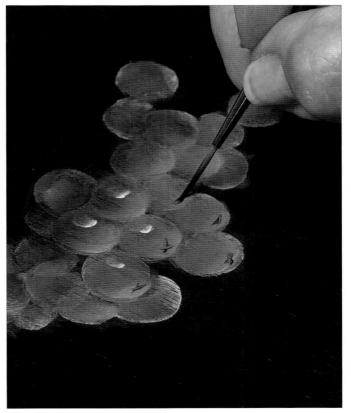

Photo 7

Berries & Leaves Painting Worksheet

Berries:

Illustration A
Undercoat with White acrylic paint. Let dry.

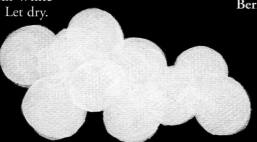

Illustration B
Cover all berries with Cadmium Red Light.

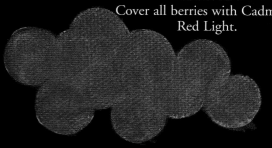

Illustration C
Brush Alizarin Crimson on the berries in the rear.

Illustration D
Stroke Cadmium Yellow Deep on the tops of the berries in front.

Illustration E
Brush Cadmium Orange on the bottoms of the berries in front.

Illustration F
Brush Cadmium Yellow Medium at center bottoms of the berries in front.

Add Asphaltum detail on the blossom ends of the berries.
Add brightest highlights with White C-strokes.

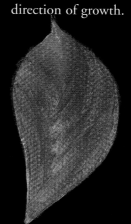

Berry Leaf:

Undercoat with White acrylic paint. Let dry.

Stroke Cadmium Yellow Deep on the leaf tips.

Stroke Metallic Gold in the direction of growth.

Shade with Asphaltum. Add Asphaltum linework.

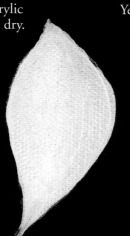

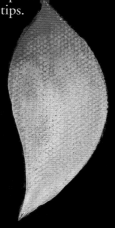

Pattern for Flavors of Fall Metal Tray
Enlarge pattern @140% for actual size.

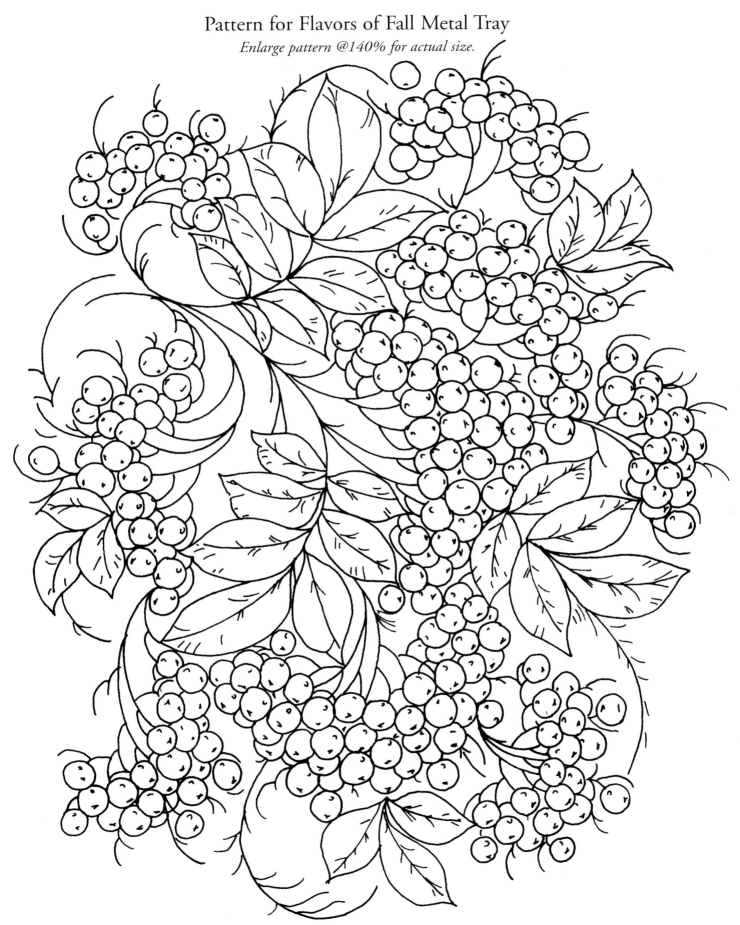

Bridal Bouquet
SCALLOPED ROUND TABLE

This bountiful bouquet uses small white blossoms as filler flowers that contrast in size and color with the red and pink roses. Notice the variations in the border that enliven the scalloped edge of this little table.

Pattern appears on pages 88 & 89.

SUPPLIES

Color Palette for Design:
Asphaltum
Burnt Sienna
Cadmium Orange
Cadmium Red Light
Cadmium Red Medium
Cadmium Red Deep
Cadmium Yellow Light
Cadmium Yellow Deep
Sap Green
Viridian
White

Acrylic Craft Paint:
White
Black
Metallic Gold

Brushes:
Filberts
Small (#2, #4, #6)
Medium (#8, #10)
Large (#12)
Liner (#1, #10/0) or scroll brush

Mediums:
Turpenoid
Linseed Oil

Painting Surface:
Round scalloped table

PAINTING INSTRUCTIONS

Preparation:
1. Sand the table. Fill any holes with wood filler, let dry, and sand again. Remove sanding dust with a tack cloth.
2. Basecoat the table by brushing on two coats of black acrylic paint. Let the paint dry and sand after each coat with a crumpled piece of brown paper bag with no printing on it. Wipe off the residue with a tack cloth.
3. Seal with matte acrylic spray, let dry, and rub again with the brown paper bag.
4. Neatly transfer the design, using chalk.

Undercoating:
1. Undercoat the design with white acrylic paint, using the same strokes and direction that you will use to paint the design. Let dry.
2. Gently scrape the entire design with a single-edged razor blade. Hold the razor blade straight up to keep from cutting into the surface. Wipe off any residue.
3. Apply a very thin layer of linseed oil to the undercoating with a small piece of cotton cloth.

Continued on page 86

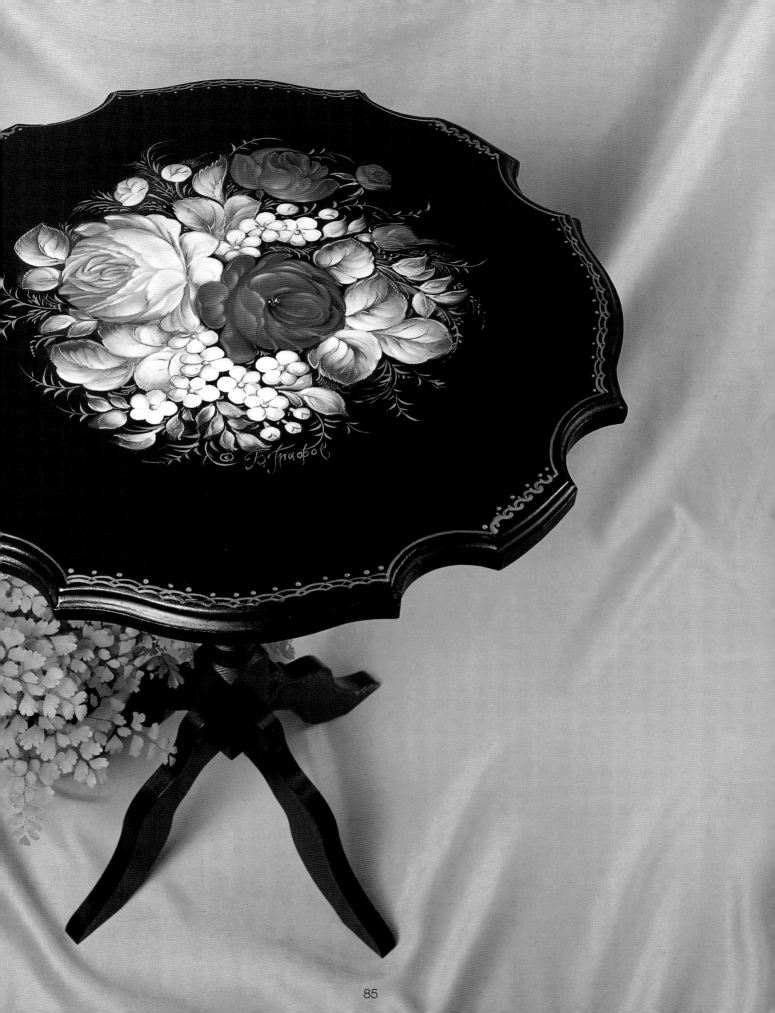

continued from page 84

Leaves:

Refer to the Basic Leaf Painting Worksheet and step-by-step photos in the "Painting Leaves" section, using colors given here. Paint the leaves with a #10 or #4 filbert brush, depending upon their size.

1. Brush Cadmium Red Medium on the tips of the leaves.
2. Brush Cadmium Yellow Light next, blending softly where the colors meet.
3. Brush mix Sap Green + Viridian. Brush over the leaves, allowing some of the colors beneath to show through. Vary the colors by using a little more Sap Green on some leaves and a little more Viridian on others.
4. Define the veins down the centers of the leaves with a brush mix of Sap Green + Viridian.
5. With White, use variations of the S-stroke to stroke highlights on the leaves.
6. Thin Cadmium Yellow Light to a flowing consistency with linseed oil and turpenoid. Thin Cadmium Red Deep to a flowing consistency with linseed oil and turpenoid. Using the #1 and #1/0 liner brushes, paint the linework on the leaves as shown in the photo of the finished project.
7. Paint the rosebud calyxes in the leaf colors, using a #4 filbert brush. Apply linework as shown.

Red Roses:

Refer to the Rose Painting Worksheet in the "Eternity" project and the "Painting a Rose" step-by-step photos in the "Basic Information" section, using colors given here. Use a #10 or #8 filbert brush, depending upon the size you are most comfortable using for the size of the petals. Paint the rosebuds with a #6 filbert brush.

1. Brush Cadmium Red Deep on the tips of the petals and the center of the rose.
2. Brush Cadmium Red Medium on the remainder of the rose, softly blending and shaping the petals as you stroke.
3. Deepen the center of the rose and lay in the shadows of the petals with Asphaltum.
4. Stroke in the front petals with Cadmium Orange.
5. Stroke Cadmium Yellow Deep highlights to shape the front petals and to form the edges of the petals of the rest of the rose.
6. Thin Cadmium Red Light to a flowing consistency with linseed oil and turpenoid. Using a #1 liner brush, paint linework on the edges of petals as shown in the photo of the finished project.
7. Use a #1 liner brush to place dots of Cadmium Yellow Deep in the center of the rose.

8. Paint the red rosebuds in the petal colors, using a #6 filbert brush. Apply linework as shown.

Coral Rose:

Refer to the Rose Painting Worksheet in the "Eternity" project and the "Painting a Rose" step-by-step photos in the "Basic Information" section, using colors given here. Paint the rose with a #12 filbert brush. Paint the buds with a #6 filbert brush.

1. Brush mix Cadmium Red Light + White. Add a touch of Burnt Sienna to make a medium coral. Paint the tips of the petals with this mix.
2. Brush mix Sap Green + Cadmium Yellow Light. Softly lay in the center and paint the bottom of the rose.
3. Mix White + a touch of Cadmium Red Light. Stroke in the front petals of the rose.
4. Stroke in White highlights to define the petals.
5. Thin Cadmium Red Deep to a flowing consistency with linseed oil and turpenoid. Use a #1 liner brush to paint the linework as shown in the photo of the finished project.
6. Use a #1 liner brush to place dots of Cadmium Yellow Light in the center of the rose.
7. Paint the coral buds in the petal colors, using a #6 filbert brush. Apply linework as shown.

Blossoms:

Refer to the Blossom Painting Worksheet and step-by-step photos in the "Moon Light" project, using colors given here. Use a #8 or #6 filbert brush, depending upon the size you are most comfortable using for the size of the petals.

1. Apply Cadmium Yellow Light in the centers of the blossoms, brushing it slightly outward onto the petals.
2. Brush Sap Green on two of the petals of each blossom, brushing from the outer tips toward the center. Vary the blossoms by brushing more Sap Green on some of the petals, less on others.
3. Brush Sap Green on the tips of some of the petals.
4. Stroke over each petal lightly with White.
5. Stroke White highlights on the petals.
6. Use a #2 filbert brush to place a dot of Cadmium Yellow Deep to create the center of each blossom.
7. Use the #2 filbert brush to highlight each center with a dot of Cadmium Yellow Light.
8. Paint the blossom buds in the petal colors, using a #6 filbert brush.
9. Thin Cadmium Red Deep to a flowing consistency with linseed oil and turpenoid. Using a #1 liner brush, paint the linework around the petals and buds as shown in the photo of the finished project.

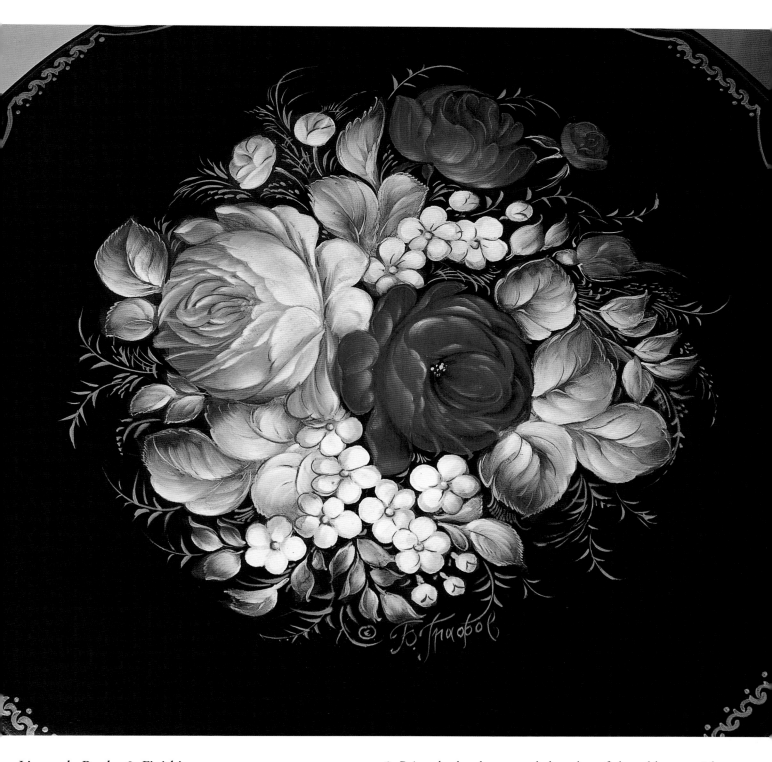

Linework, Border & Finishing:

Refer to the Linework Filler Ornamentation Painting Worksheet and the border examples in the "Painting Borders" section.

1. Thin a mix of Prussian Blue + White to a flowing consistency with linseed oil and turpenoid. Use #1 and #10/0 liner brushes, depending upon the size of the lines, to paint ornamental linework "grasses" to fill in the design. Let dry.

2. Paint the border around the edge of the table top with thinned Metallic Gold. Use a #2 filbert brush for the heavier strokes and a #1 liner brush for the finer strokes of the border. Dip the handle end of the brush into the paint, then touch to the surface to apply dots. Let all paint dry and cure.

3. Following the directions in the "Varnishing" section, apply a glossy finish to the table. ❏

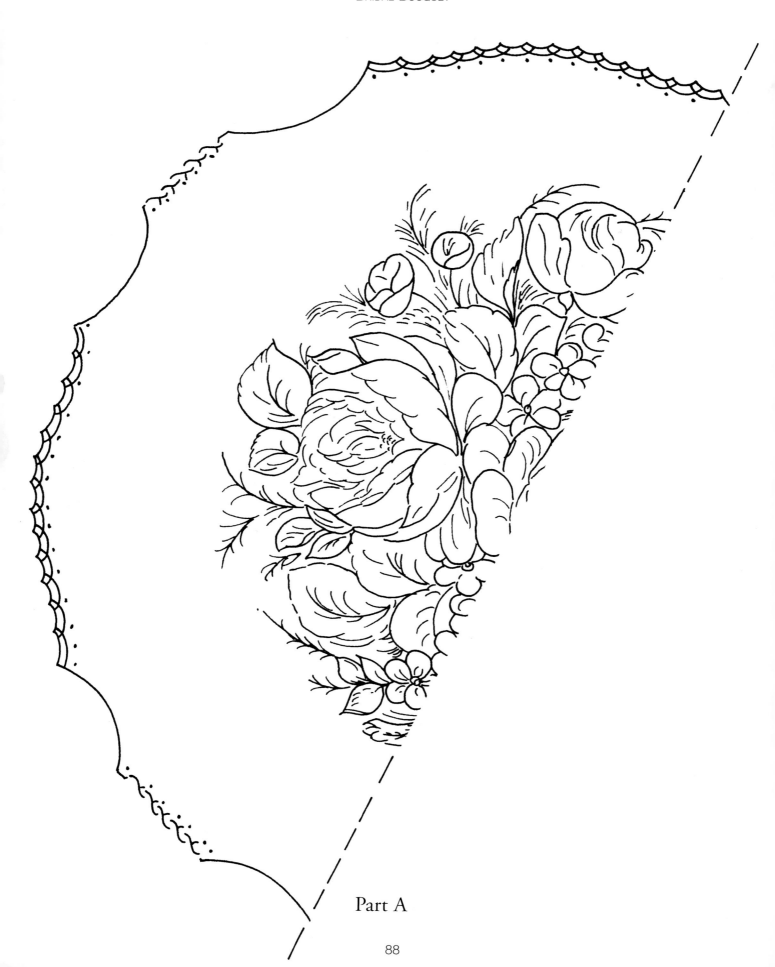

Part A

Pattern for Bridal Bouquet Scalloped Round Table

Enlarge @170% for actual size.

Connect Part A to Part B at dotted
lines to complete pattern.

Part B

Pyramid of Roses
TRIANGULAR MUSIC BOX TABLE

The unusual triangular shape of this table draws extra attention to a stunning arrangement of deep red roses with lavender-accented petals.

Pattern appears on page 93.

SUPPLIES

Color Palette for Design:
Alizarin Crimson
Cadmium Red Light
Cadmium Red Medium
Cadmium Red Deep
Cadmium Yellow Medium
Prussian Blue
Sap Green
Viridian
White

Acrylic Craft Paint:
White
Black
Metallic Gold

Brushes:
Filberts
Small (#2, #4, #6)
Medium (#8, #10)
Liner (#1, #10/0) or scroll brush

Mediums:
Turpenoid
Linseed Oil

Painting Surface:
Triangular music box table

PAINTING INSTRUCTIONS

Preparation:
1. Sand the music box table. Fill any holes with wood filler, let dry, and sand again. Remove sanding dust with a tack cloth.
2. Basecoat the table by brushing on two coats of black acrylic paint. Let the paint dry and sand after each coat with a crumpled piece of brown paper bag with no printing on it. Wipe off the residue with a tack cloth.
3. Seal with matte acrylic spray, let dry, and rub again with the brown paper bag.
4. Neatly transfer the design, using chalk.

Undercoating:
1. Undercoat the design with white acrylic paint, using the same strokes and direction that you will use to paint the design. Let dry.
2. Gently scrape the entire design with a single-edged razor blade. Hold the razor blade straight up to keep from cutting into the surface. Wipe off any residue.
3. Apply a very thin layer of linseed oil to the undercoating with a small piece of cotton cloth.

Leaves & Stems:
Refer to the Basic Leaf Painting Worksheet and step-by-step photos in the "Painting Leaves" section, using colors given here. Paint the leaves with the brush sizes you are most comfortable using for the size of the leaves, ranging from a #10 filbert brush for the largest leaves to a #6 for the smallest leaves.
1. Brush Alizarin Crimson on the stems. Overstroke with a brush mix of Prussian Blue + Viridian. Vary the colors of the stems by overstroking more in some areas than in other areas.
2. Brush Alizarin Crimson on the tips of some of the leaves, and a brush mix of Prussian Blue + Viridian on the tips of other leaves.
3. Brush mix Sap Green + Viridian. Brush over the leaves, allowing some of the colors beneath to show through. Vary the colors of the leaves by using a little more Sap Green on some leaves and a little more Viridian on others. Add some touches to the stems.
4. With a brush mix of Prussian Blue + Viridian, define the vein lines down the centers of the leaves with the tip of the brush. Add some touches to the stems.
5. Mix White + a touch of Prussian Blue on the palette to make an ice blue. Use variations of the S-stroke to stroke highlights on the leaves.
6. Paint the rosebud calyxes in the leaf colors, using the #4 filbert brush.
7. Thin White to a flowing consistency with linseed oil and turpenoid. Using a #10/0 liner brush, paint the linework as shown in the photo of the finished project.

Continued on page 92

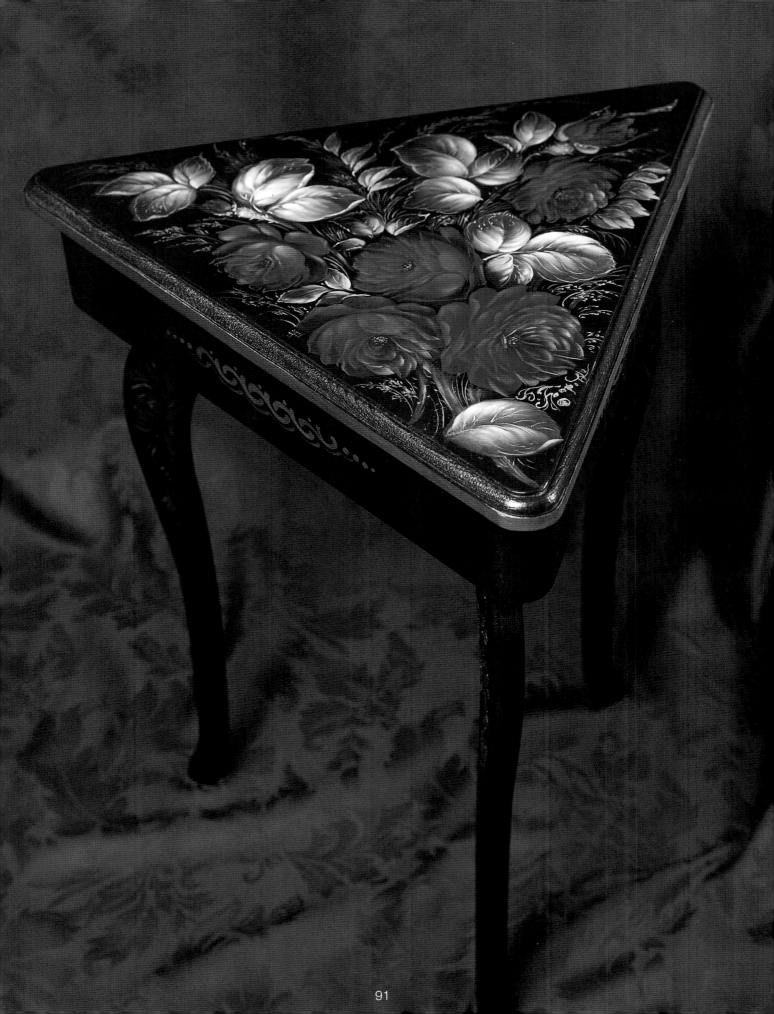

continued from page 90

8. Thin Viridian to a flowing consistency with linseed oil and turpenoid. Using the #10/0 liner brush, paint additional linework as shown.

Roses:

Refer to the Rose Painting Worksheet in the "Eternity" project and the "Painting a Rose" step-by-step photos in the "Basic Information" section, using colors given here. Paint the roses with the brush size you are most comfortable using for the size of the petals, ranging from a #10 filbert brush for the largest petals to a #6 for the smallest petals. Paint the rosebuds with a #4 filbert brush.

1. Brush Alizarin Crimson on the tips of the petals and the center of the rose.
2. Brush Cadmium Red Deep on the remainder of the rose, softly blending and shaping the petals as you stroke.
3. Lay in the shadows with a deep lavender brush mix of Alizarin Crimson + Prussian Blue + White. Work from the back to the center front.
4. Stroke in the front petals with Cadmium Red Medium.
5. Stroke Cadmium Red Light highlights to shape the front petals and to form the edges of the petals of the rest of the rose.

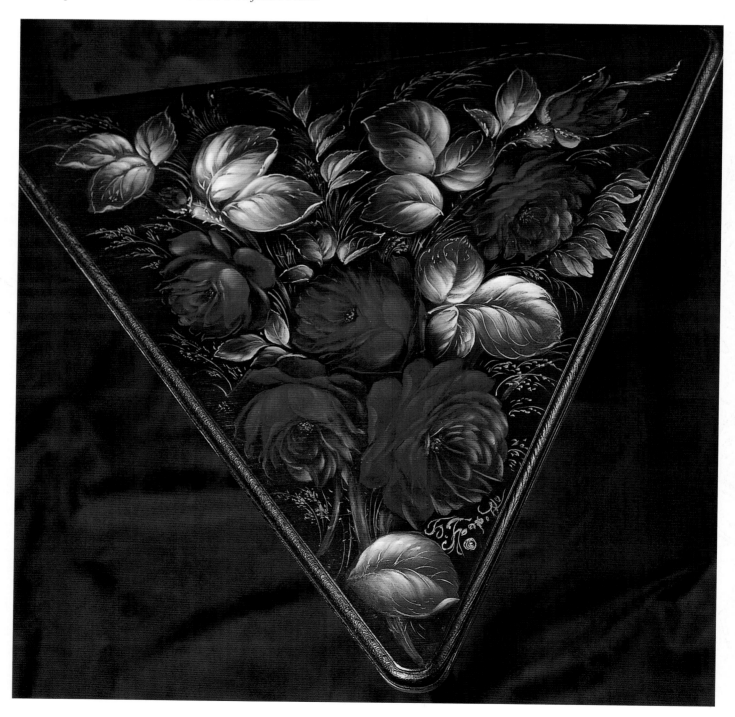

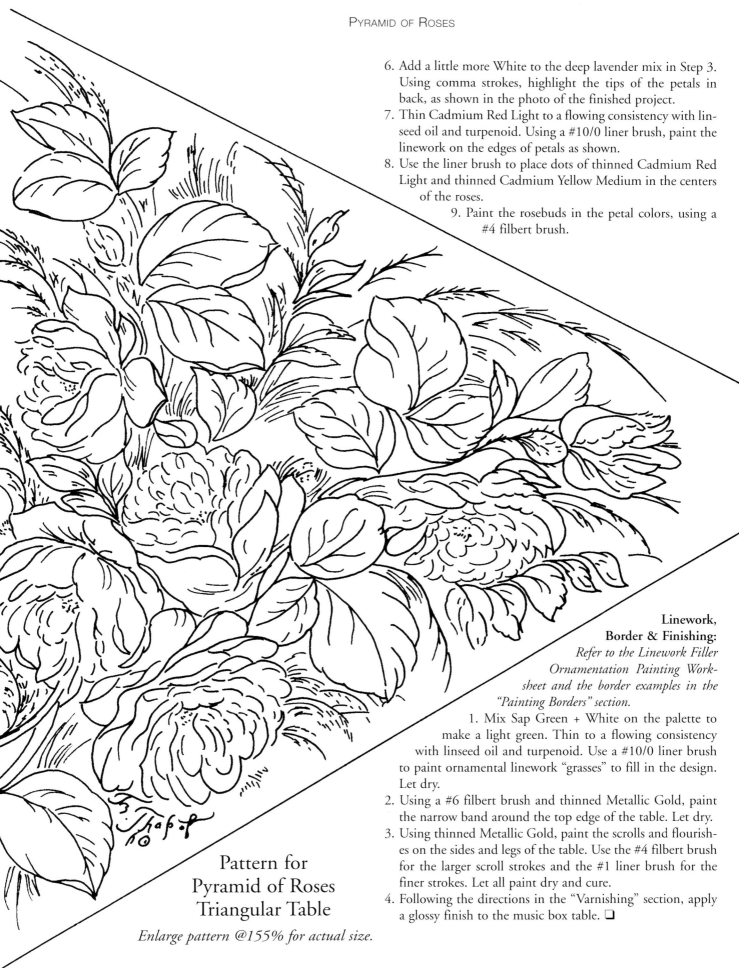

6. Add a little more White to the deep lavender mix in Step 3. Using comma strokes, highlight the tips of the petals in back, as shown in the photo of the finished project.

7. Thin Cadmium Red Light to a flowing consistency with linseed oil and turpenoid. Using a #10/0 liner brush, paint the linework on the edges of petals as shown.

8. Use the liner brush to place dots of thinned Cadmium Red Light and thinned Cadmium Yellow Medium in the centers of the roses.

9. Paint the rosebuds in the petal colors, using a #4 filbert brush.

Linework, Border & Finishing:

Refer to the Linework Filler Ornamentation Painting Worksheet and the border examples in the "Painting Borders" section.

1. Mix Sap Green + White on the palette to make a light green. Thin to a flowing consistency with linseed oil and turpenoid. Use a #10/0 liner brush to paint ornamental linework "grasses" to fill in the design. Let dry.

2. Using a #6 filbert brush and thinned Metallic Gold, paint the narrow band around the top edge of the table. Let dry.

3. Using thinned Metallic Gold, paint the scrolls and flourishes on the sides and legs of the table. Use the #4 filbert brush for the larger scroll strokes and the #1 liner brush for the finer strokes. Let all paint dry and cure.

4. Following the directions in the "Varnishing" section, apply a glossy finish to the music box table. ❑

Pattern for
Pyramid of Roses
Triangular Table

Enlarge pattern @155% for actual size.

Symphony in Red and Blue
METAL TRAY

This exciting design is a brilliant example of how contrasting colors, sizes,
and textures bring drama into a painting.

Color worksheets appear on pages 96 & 97.

SUPPLIES

Color Palette for Design:
Asphaltum
Alizarin Crimson
Cadmium Red Light
Cadmium Red Medium
Cadmium Red Deep
Cadmium Yellow Light
Cadmium Yellow Medium
Ultramarine Blue
Prussian Blue
Sap Green
Viridian
White

Spray Paint:
Flat black

Acrylic Craft Paint:
White
Metallic Gold

Brushes:
Filberts
Small (#2, #4, #6)
Medium (#8, #10)
Large (#12)
Liner (#1, #10/0) or scroll brush

Mediums:
Turpenoid
Linseed Oil

Painting Surface:
Primed metal tray

PAINTING INSTRUCTIONS

Preparation:
1. Basecoat the tray by spraying on two or three coats of flat black paint. Let the paint dry and sand after each coat with very soft, fine steel wool. Wipe off all residue with a tack cloth. Sand after the last coat with a crumpled piece of brown paper bag with no printing on it. Wipe with a tack cloth.
2. Seal with matte acrylic spray. Let dry. Rub lightly again with the brown bag. Wipe off residue with the tack cloth.
3. Neatly transfer the design, using chalk.

Undercoating:
1. Undercoat the design with white acrylic paint, using the same strokes and direction that you will use to paint the design. Let dry.
2. Gently scrape the entire design with a single-edged razor blade. Hold the razor blade straight up to keep from cutting into the surface. Wipe off any residue.
3. Rub with the brown paper bag. Remove all residue with the tack cloth.
4. Apply a very thin layer of linseed oil to the undercoating with a small piece of cotton cloth.

Leaves:
Refer to the Blade Leaf Painting Worksheet in the "Painting Leaves" section and to the step-by-step photos in the "Time for Tulips" project, using colors given here. Paint the leaves with the brush sizes you are most comfortable using for the size of the leaves, ranging from a #12 filbert brush for the largest leaves to a #6 for the smallest leaves.
1. Brush Alizarin Crimson on the tips and at the base of the leaves.
2. Brush mix Sap Green + Viridian. Brush on the center areas of the leaves, blending softly where the colors meet.
3. Define the deepest shaded areas of each leaf with Prussian Blue.
4. Brush Cadmium Yellow Medium on the right edges of the leaves. Softly blend all colors.
5. Stroke highlights with White, using variations of the S-stroke and following the natural curves of the leaves, as shown in the photo of the finished project.
6. Thin White to a flowing consistency with linseed oil and turpenoid. Thin Cadmium Red Medium to a flowing consistency with linseed oil and turpenoid. Using a #1 liner brush, paint the linework as shown.

Continued on page 96

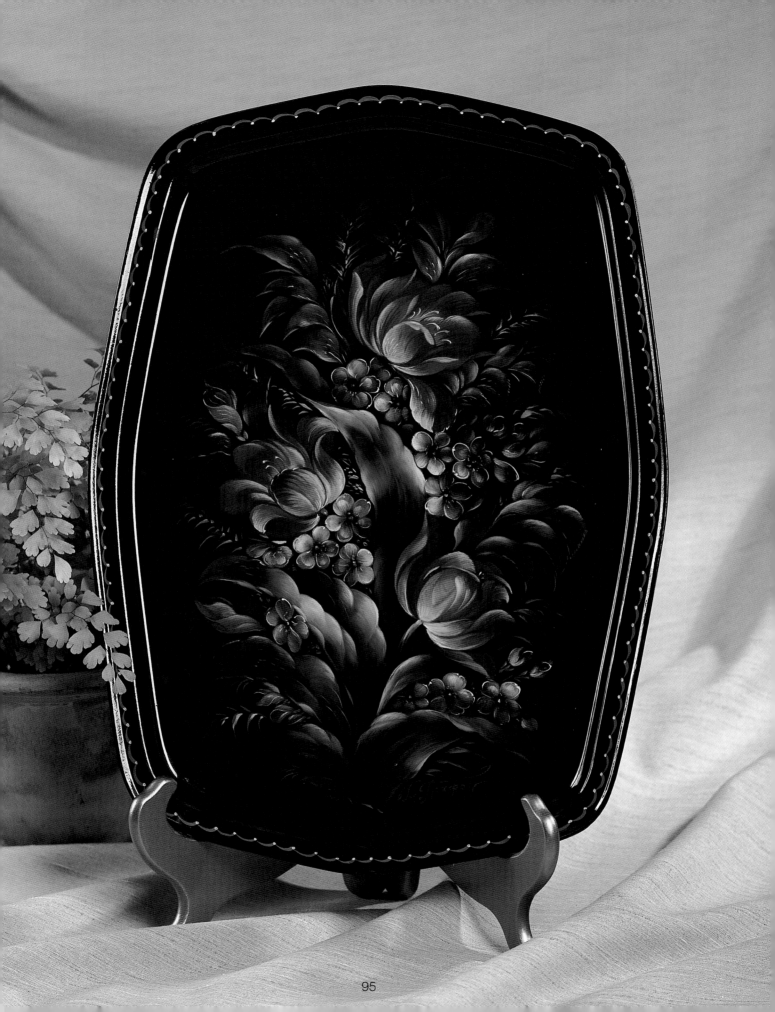

continued from page 94

Tulips:

Refer to the Red Tulip Painting Worksheet and to the step-by-step photos in the "Time for Tulips" project, using colors given here. Use a #10 or #8 filbert brush, depending upon the size of the petals.

1. Brush Cadmium Yellow Light in the center of the tulip and at the base of the front petal.
2. Brush Cadmium Red Deep on the tips of the petals and at the base of the darkest petal.
3. Stroke in the deep shadows with a brush mix of Asphaltum + Cadmium Red Deep, using S-strokes.
4. Stroke in the petals with Cadmium Red Light.
5. Softly stroke the highlights with White, shaping the petals as you stroke.
6. Thin White to a flowing consistency with linseed oil and turpenoid. Thin Cadmium Yellow Medium to a flowing consistency with linseed oil and turpenoid. Using a #1 liner brush, paint the linework on the edges of the petals and in the centers, as shown in the photo of the finished project.
7. Paint the tulip buds in the petal colors. Apply linework as shown.

Blue Blossoms:

Refer to the Blue Blossom Painting Worksheet. Use a #8 or #6 filbert brush, depending upon the size of the petals.

1. Brush mix Ultramarine Blue + White + Cadmium Red Deep. Stroke the petals. Vary the depth of color by using slightly more of one color on some petals and slightly more of another color on other petals.
2. Brush White highlights on the petals.
3. Using a #2 filbert brush, make a circle of Cadmium Red Deep for the center of each blossom.
4. Dip the handle end of the brush into Cadmium Yellow Medium, then touch to the surface to place dots around the blossom centers.
5. Thin White to a flowing consistency with linseed oil and turpenoid. Using a #10/0 liner brush, paint the linework on the petals as shown in the photo of the finished project.
6. Paint the blossom buds in the petal colors. Apply linework as shown.

Linework, Border & Finishing:

Refer to the Linework Filler Ornamentation Painting Worksheet and the border examples in the "Painting Borders" section.

1. Thin Sap Green to a flowing consistency with linseed oil and turpenoid. Thin Viridian to a flowing consistency with linseed oil and turpenoid. Using a #1 liner brush, paint ornamental linework "grasses" to fill in the design. Let dry.
2. Using a #1 liner brush and thinned Metallic Gold, paint a border around the tray.
3. Thin White slightly with linseed oil and turpenoid. Dip the handle end of the brush into the paint, then touch to the surface to apply dots. Let all paint dry and cure.
4. Following the directions in the "Varnishing" section, apply a glossy finish to the tray. ❑

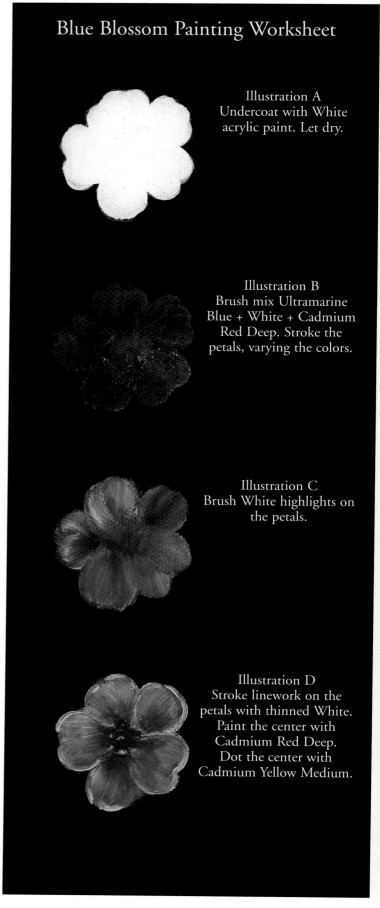

Blue Blossom Painting Worksheet

Illustration A
Undercoat with White acrylic paint. Let dry.

Illustration B
Brush mix Ultramarine Blue + White + Cadmium Red Deep. Stroke the petals, varying the colors.

Illustration C
Brush White highlights on the petals.

Illustration D
Stroke linework on the petals with thinned White. Paint the center with Cadmium Red Deep. Dot the center with Cadmium Yellow Medium.

Red Tulip Painting Worksheet

Illustration A
Undercoat with White
acrylic paint. Let dry.

Illustration B
Brush Cadmium Yellow Light in the center
and at the base of
the front petal.

Illustration C
Stroke Cadmium Red Deep
on the tips of the petals.

Illustration D
Stroke in the shadows with a brush mix
of Asphaltum + Cadmium Red Deep.

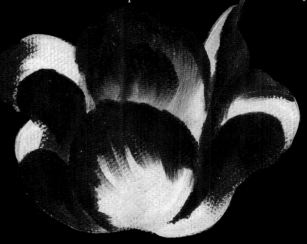

Illustration E
Brush Cadmium Red Light
on the petals.

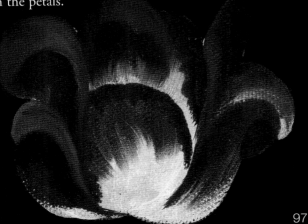

Illustration F
Stroke highlights with White.
Paint the linework with thinned White and
thinned Cadmium Yellow Medium.

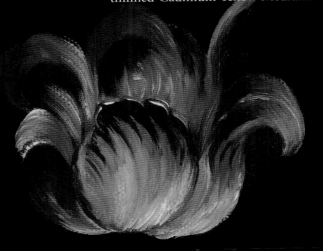

Pattern for Symphony in Red and Blue Metal Tray

Enlarge pattern @165% for actual size.

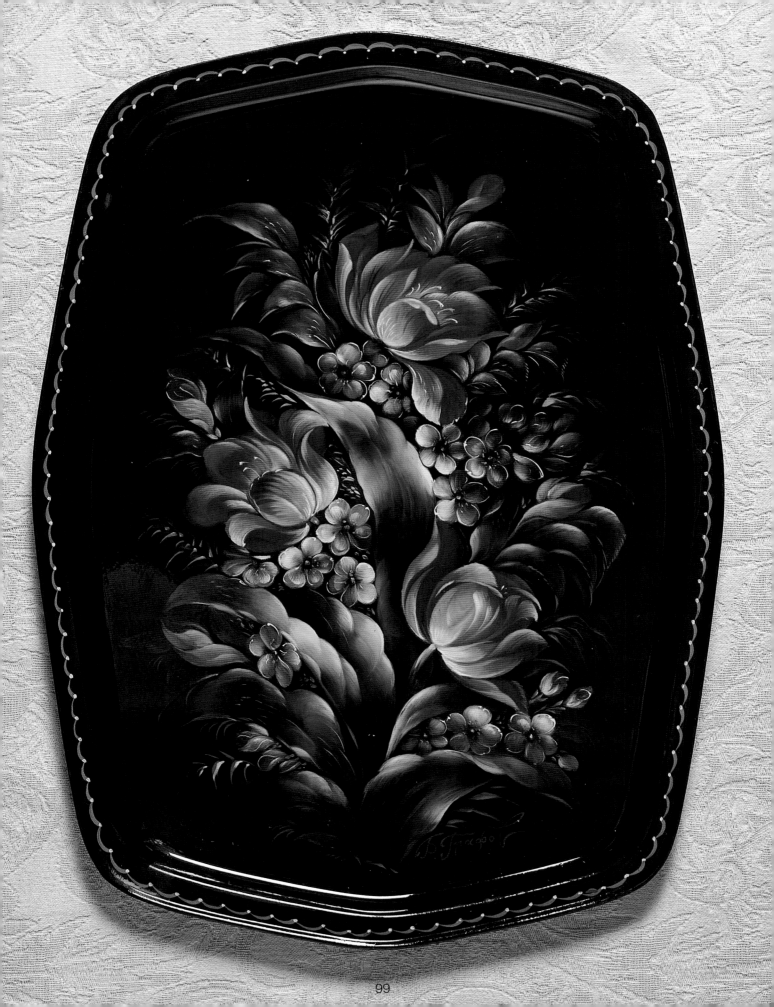

Golden Medley
BUTTERFLY BOX

The most valuable element of all-gold-sets the color theme for this unforgettable design. Even if you have not worked with gold leaf before, you will find it easy to apply when you follow the instructions and step-by-step photos.

Color worksheet appears on page 104.
Pattern appears on page 106.

SUPPLIES

Color Palette:
Asphaltum
Cadmium Orange
Cadmium Red Light
Cadmium Red Deep
Cadmium Yellow Light
Cadmium Yellow Medium
Sap Green
White

Acrylic Craft Paint:
White
Black
Metallic Gold

Brushes:
Filberts
Small (#4, #6)
Medium (#8, #10)
Large (#12)
Liner (#1, #10/0) or scroll brush

Mediums:
Turpenoid
Linseed Oil
Gold leaf
Liquid gold leaf sizing

Painting Surface:
Wooden butterfly box

PAINTING INSTRUCTIONS

Preparation:
1. Sand the box. Fill any holes with wood filler, let dry, and sand again. Remove sanding dust with a tack cloth.
2. Basecoat the box by brushing on two coats of black acrylic paint. Let the paint dry and sand after each coat with a crumpled piece of brown paper bag with no printing on it. Wipe off the residue with a tack cloth.
3. Seal with matte acrylic spray, let dry, and rub again with the brown paper bag.
4. Neatly transfer the design, using chalk. Transfer only the outline of the roses.

Undercoating:
1. Undercoat the design, except for the roses, with white acrylic paint, using the same strokes and direction that you will use to paint the design. Let dry.
2. Gently scrape the undercoated parts of the design with a single-edged razor blade. Hold the razor blade straight up to keep from cutting into the surface. Wipe off any residue.
3. Apply a very thin layer of linseed oil to the undercoating with a small piece of cotton cloth.

Continued on page 102

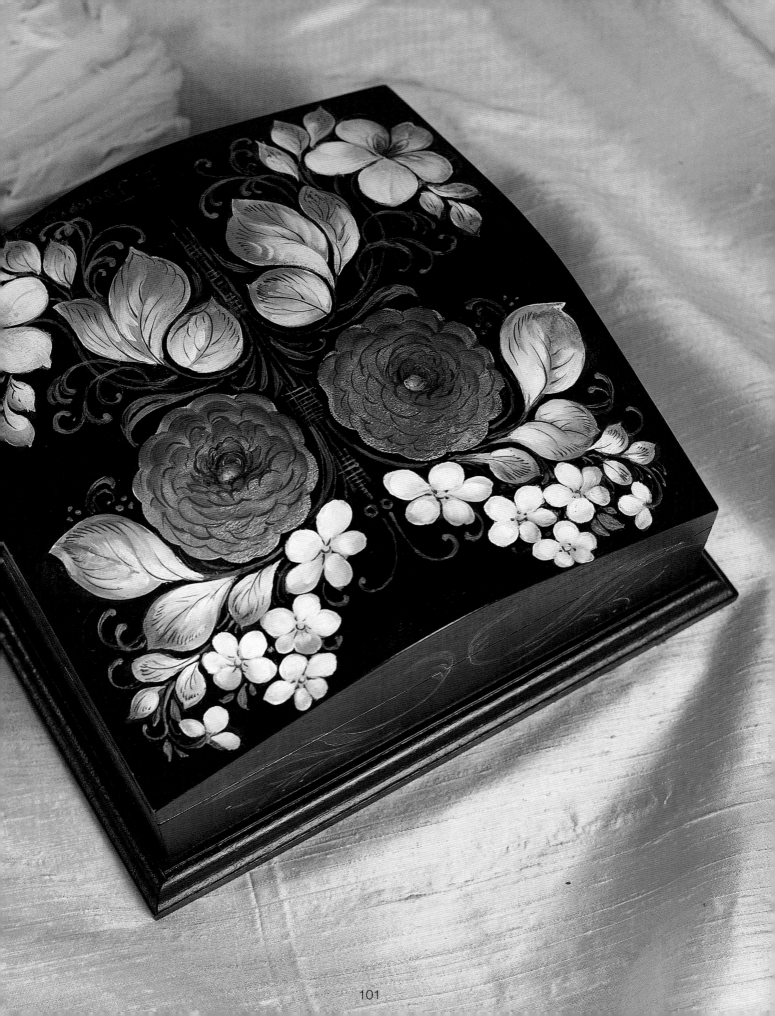

continued from page 100

Leaves:

Refer to the Basic Leaf Painting Worksheet and step-by-step photos in the "Painting Leaves" section, using colors given here. Paint the leaves with the brush sizes you are most comfortable using for the size of the leaves, ranging from a #12 filbert brush for the largest leaves to a #4 for the smallest leaves.

1. Brush Cadmium Orange on the tips of the leaves.
2. Brush a light layer of Cadmium Yellow Medium next, blending softly where the colors meet.
3. With White, use variations of the S-stroke to stroke highlights on the leaves.
4. Thin Cadmium Red Deep to a flowing consistency with linseed oil and turpenoid. Using a #1/0 liner brush, paint the linework up the centers and on the sides of the leaves as shown in the photo of the finished project.

Blossoms:

Refer to the Blossom Painting Worksheet and step-by-step photos in the "Moon Light" project, using colors given here. Paint the petals with the brush sizes you are most comfortable using for the size of the petals, ranging from a #10 filbert brush for the largest petals to a #4 for the smallest petals.

1. Brush Cadmium Yellow Light in the centers of the blossoms, brushing it slightly outward onto the petals.
2. Brush Sap Green on some of the petals, as shown in the photo of the finished project.
3. Brush Sap Green on the tips of the petals. Blend softly. Vary the amounts of Sap Green on the petals, as shown.
4. Lightly stroke White over each petal, blending softly with the colors beneath.
5. Stroke White highlights on the petals.
6. Place a dot of Cadmium Yellow Light in the center of each blossom.
7. Thin Cadmium Red Deep to a flowing consistency with linseed oil and turpenoid. Using a #1/0 liner brush, paint the linework in the centers of the blossoms, as shown in the photo of the finished project.

Applying Gold Leaf:

The surface must be clean and sealed.

1. Apply a thin coat of liquid gold leaf adhesive size to the surface. The size will be milky white. (See Photo 1.)
2. Let the adhesive size set until it is tacky and clear, usually 30 to 60 minutes.
3. Do not touch the gold leaf sheets with your hands. Cut a piece of wax paper a little larger than the piece of gold leaf you wish to pick up. Lay the piece of wax paper on top of the gold leaf. Rub your hands together for a few

Photo 1

seconds, lay your hand on the wax paper, and the leaf will stick to the wax paper. Pick it up, then gently lay the leaf on the sized surface. (See Photo 2 and 3.)

4. Gently rub over the area before removing the wax paper to be sure the leaf is adhered. Let dry. (See Photo 4.)
5. To burnish, rub gently with a soft velvet cloth or a soft brush.

Gold Leaf Rose:

Refer to the Gold Leaf Rose Painting Worksheet. Paint the roses with a #8 filbert brush.

1. When the sizing has dried and the gold leaf has been burnished, reapply the pattern if necessary.
2. Double load a dirty brush with a brush mix of Cadmium Red Light + Asphaltum. Begin to define petals by stroking the scallops at the top half of the rose. (See Photo 5.)
3. With the same mix, stroke the next layer of quarter-circle petals.
4. Stroke the petals around the bottom of the rose with Cadmium Orange.
5. Lay in the center of the rose with Asphaltum + a touch of Cadmium Red Light.
6. Thin Cadmium Red Deep to a flowing consistency with linseed oil and turpenoid. Using a #1 liner brush, paint the linework that indicates the petal edges, following the pattern.
7. Brush a circle of Cadmium Yellow Medium in the center of the rose.

Photo 2

Photo 3

Photo 4

Photo 5

8. Thin Asphaltum to a flowing consistency with linseed oil and turpenoid. Using the #1 liner brush, stroke the finishing details around the center.

Linework, Border & Finishing:
Refer to the Linework Filler Ornamentation Painting Worksheet and the border examples in the "Painting Borders" section.
1. Using #1 and #10/0 liner brushes and thinned Metallic Gold, paint ornamental linework "grasses" to fill in the design. Let dry.

2. Paint the linework in the center of the design with thinned Metallic Gold, using the #1 and #10/0 liner brushes. Dip the handle end of the brush into the paint, then touch to the surface to apply dots.
3. Using the #1 and #10/0 liner brushes and thinned Metallic Gold, paint the flourishes on the sides of the box. Let all paint dry and cure.
4. Following the directions in the "Varnishing" section, apply a glossy finish to the box. ❏

Gold Leaf Rose Painting Worksheet

Illustration A
Transfer the pattern for the
outline of the rose.

Illustration B
Apply the gold leaf.
Let dry.

Illustration C
Double load a dirty brush
with a brush mix of
Cadmium Red Light +
Asphaltum. Stroke the
back petals.

Illustration D
Continue stroking petals.
Lay in the center with Asphaltum + a touch of Cadmium
Red Light. Stroke the front petals with Cadmium Orange.

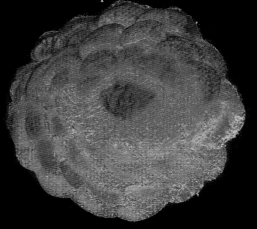

Illustration E
Stroke the linework with thinned
Cadmium Red Deep.

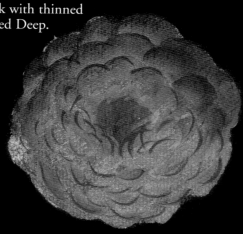

Illustration F
Stroke the center details with
thinned Asphaltum.

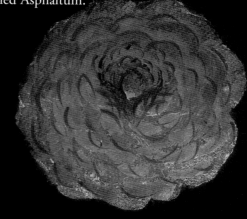

Pattern for Golden Medley Butterfly Box
Actual Size

Collectors' Gallery

Here are some beautiful examples of Zhostovo painting. Now that you have learned its basic techniques, you can admire these pieces with an educated appreciation for the rich colors and endless variations of this Russian folk art style. Today, the works of Zhostovo artists are displayed in museums and exhibitions not only in Russia, but also in many countries around the world.

"Zhostovo trays are increasingly acquiring the meaning of decorative objects rather than a mere household utensil by virtue of the special importance of their painting. Our trays are both beautiful and meaningful. At first sight the painting seems to be finishing off and adorning the tray, but there is more to it than meets the eye . . . Take a closer look and you'll be enchanted with the meaning of the bouquet . . . Every flower is looking at you and telling you something, or reminding you of something. These flowers are inimitable and always different, each with its own original character, and even the artist himself will not be able to produce the same bouquet."

Boris Grafov

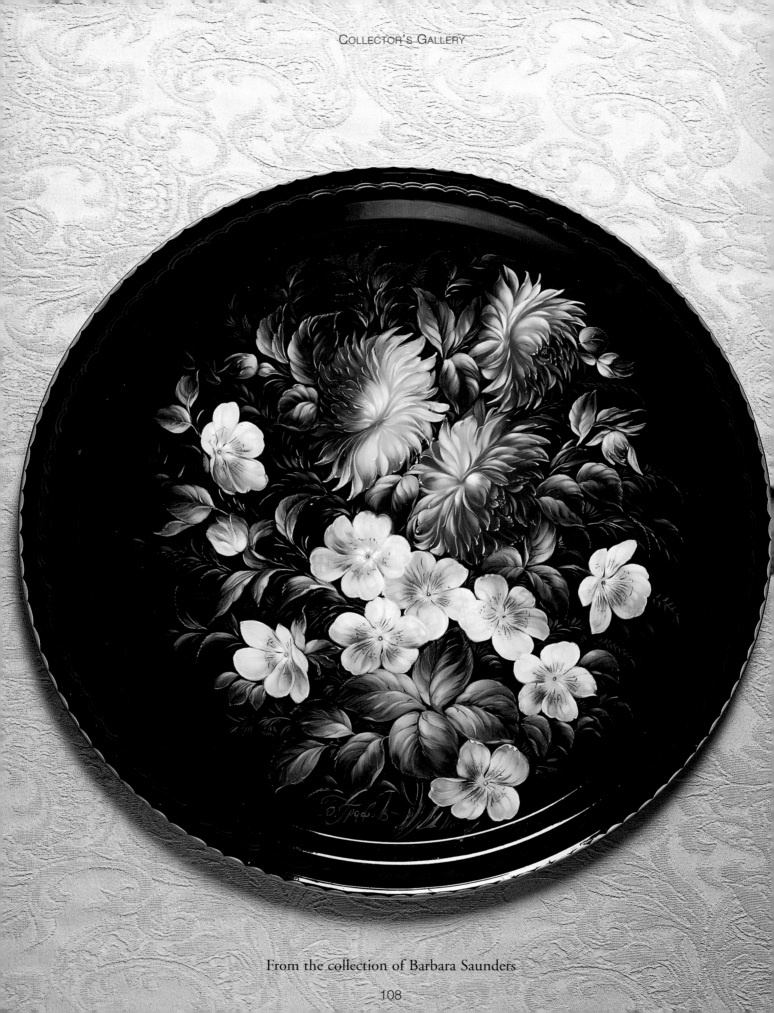

From the collection of Barbara Saunders

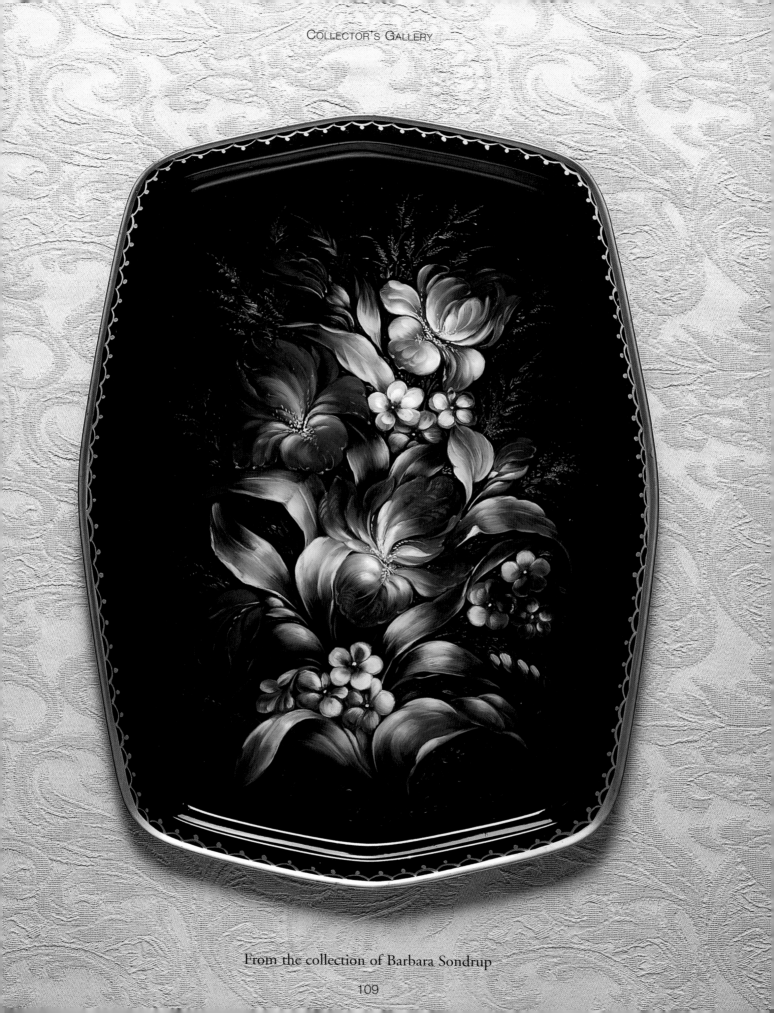

From the collection of Barbara Sondrup

Background Colors

The backgrounds of Zhostovo trays are usually black, but green, blue, different shades of red, and gold are also used. First the trays are primed, then three coats of lacquer are applied. The trays are dried and polished after each coat. Only then does the artist begin to paint.

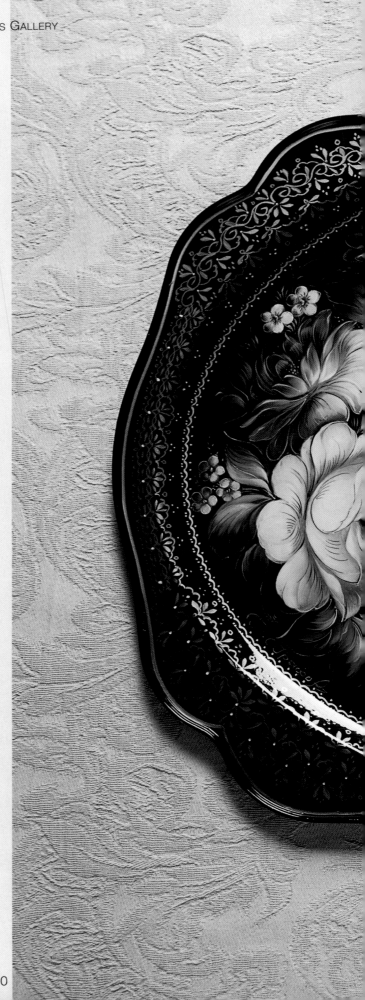

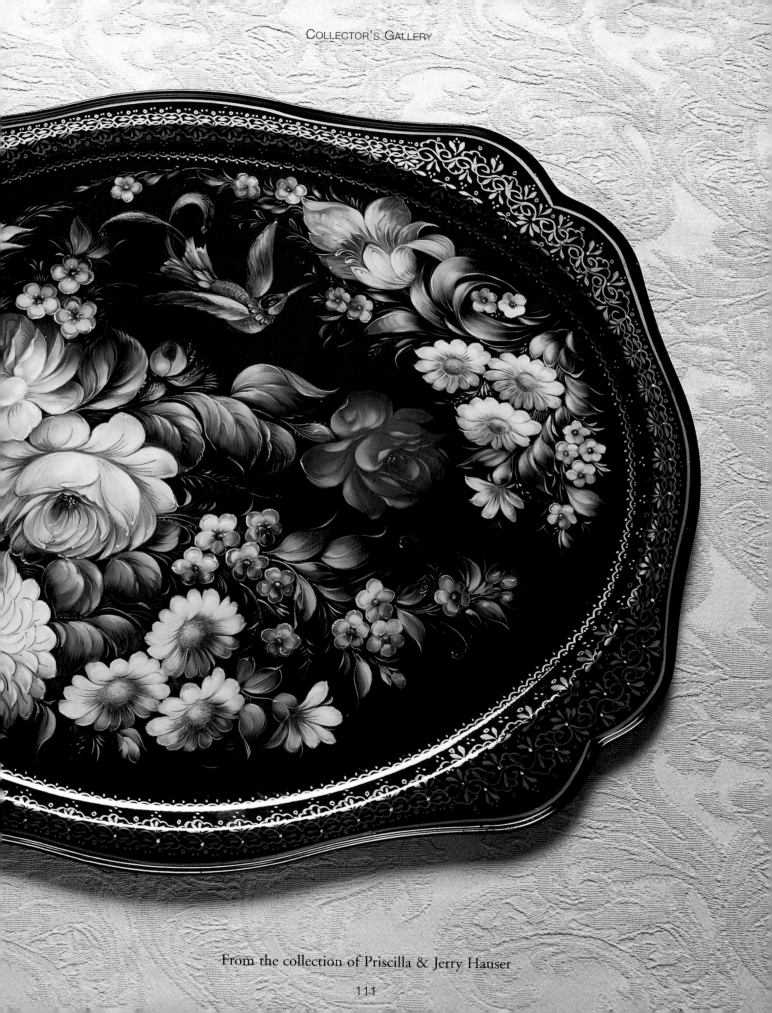

From the collection of Priscilla & Jerry Hauser

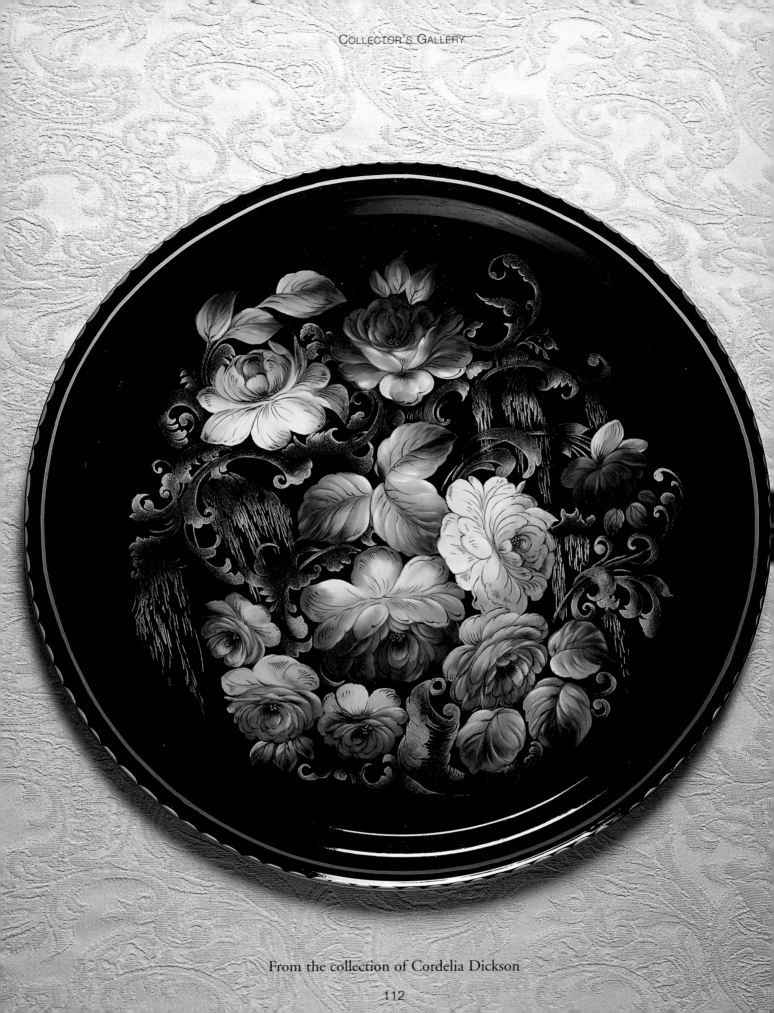

From the collection of Cordelia Dickson

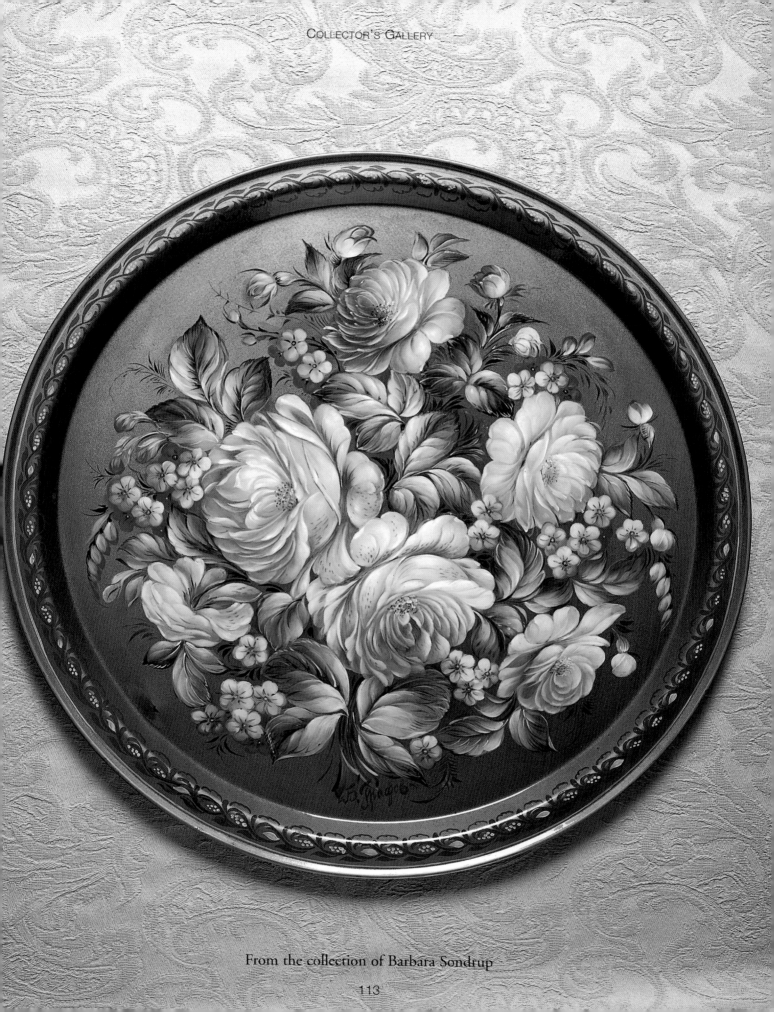

From the collection of Barbara Sondrup

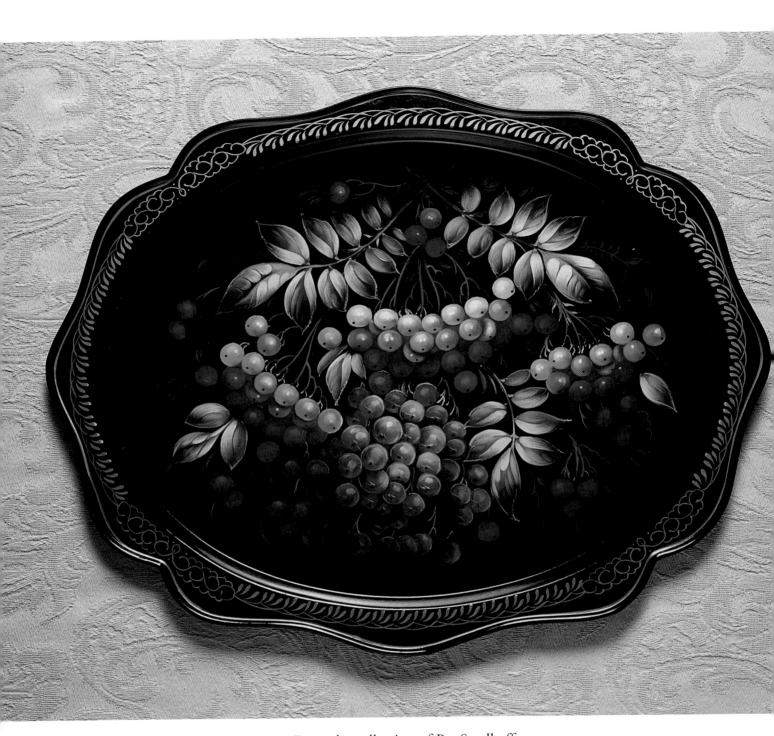

From the collection of Pat Smelkoff

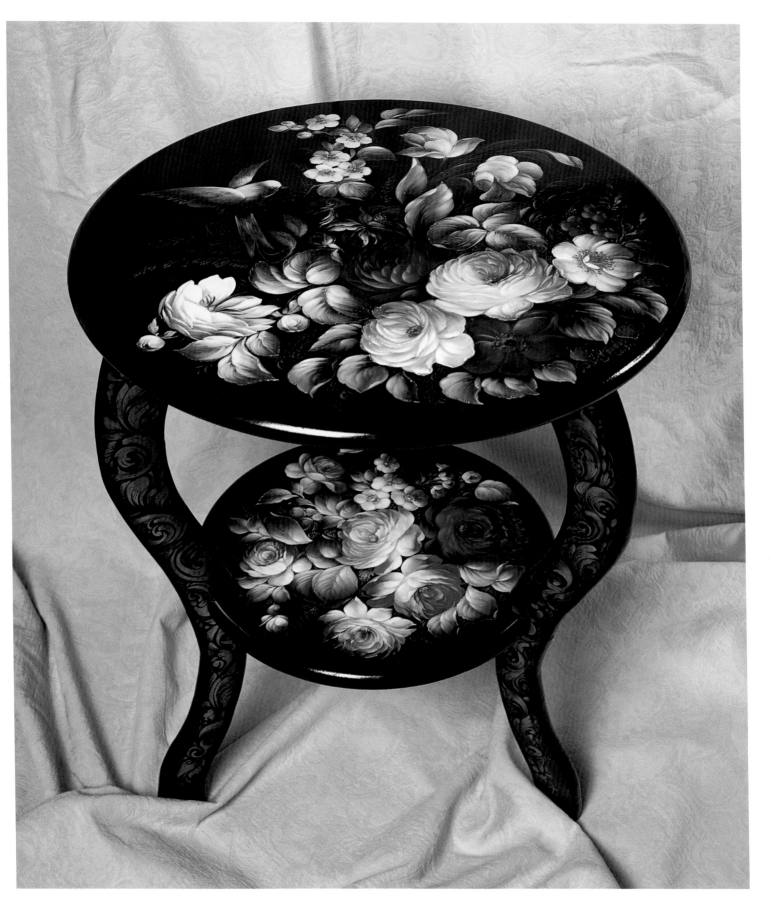

From the collection of Pat Pepper

Every Tray an Original

The artist draws the silhouettes of flowers and leaves to gather the bouquet on the tray before beginning to paint. He paints quickly and accurately, holding the tray on his lap and rotating it. He is seeking a balance between shading and highlights, and harmony between the floral composition and the size and shape of the tray. He never repeats all the details of a painting. Because the colors are mixed with the brush on the palette, each stroke is unique. Every tray is an original.

From the collection of Barbara Sondrup

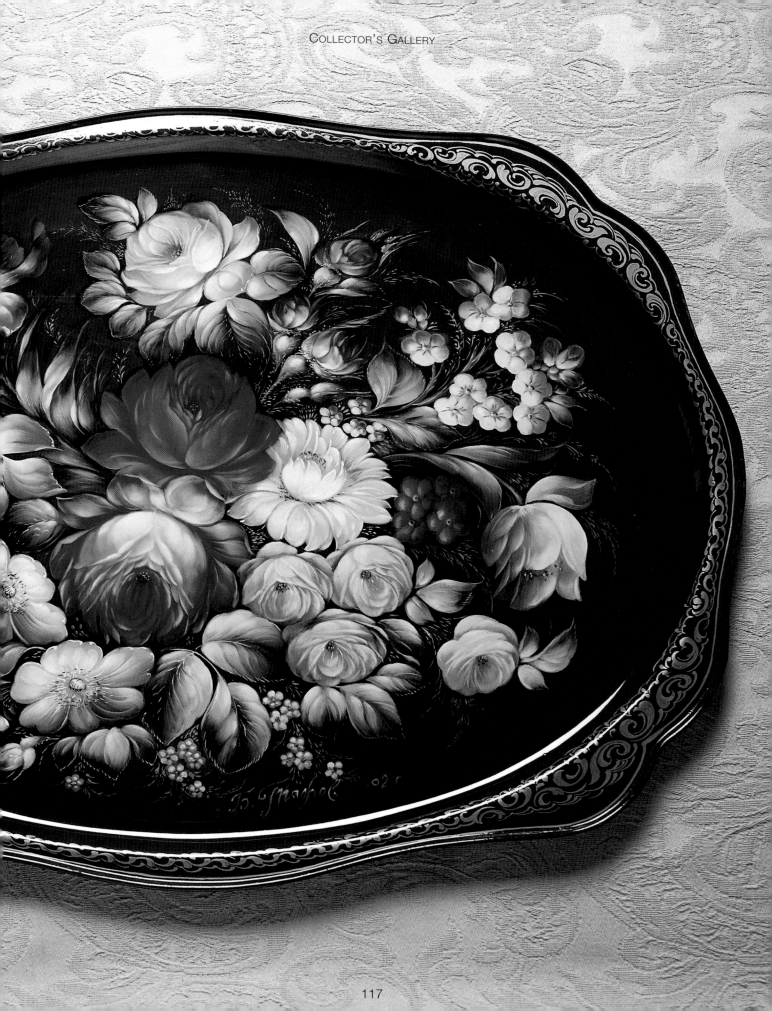

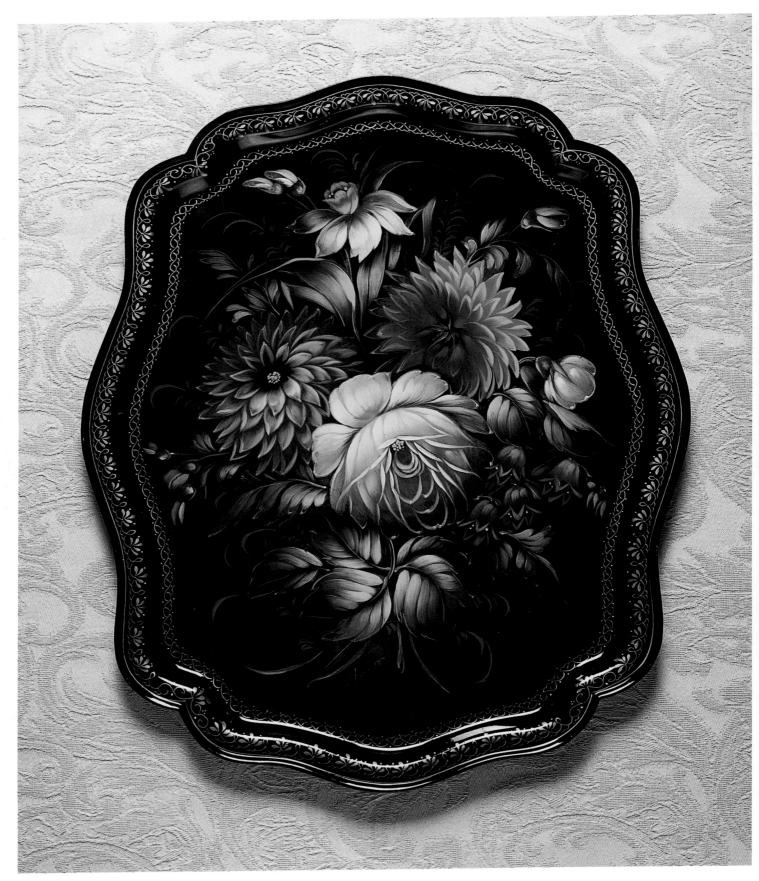

From the collection of Janet Greer

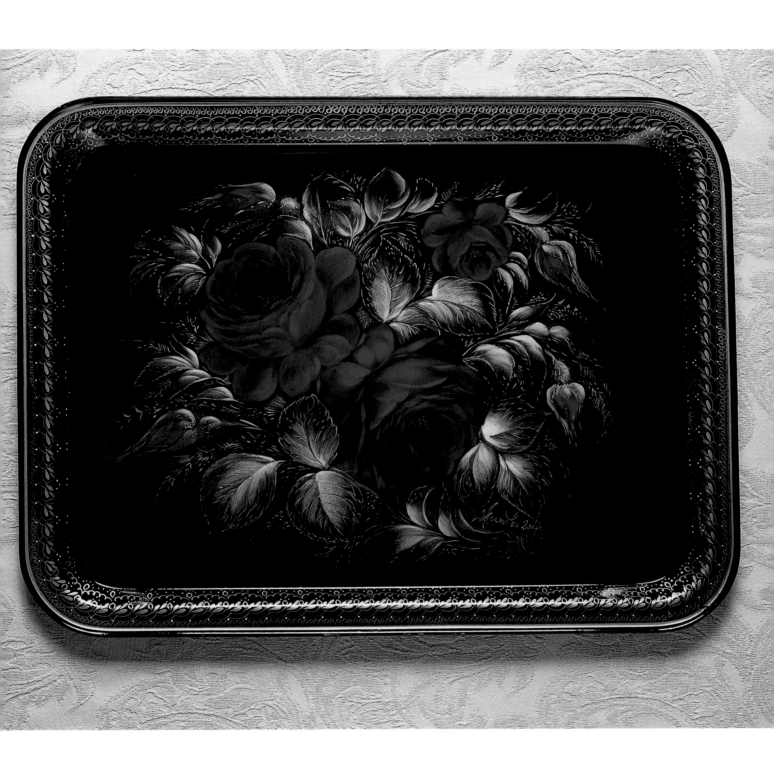

From the collection of Pat Smelkoff

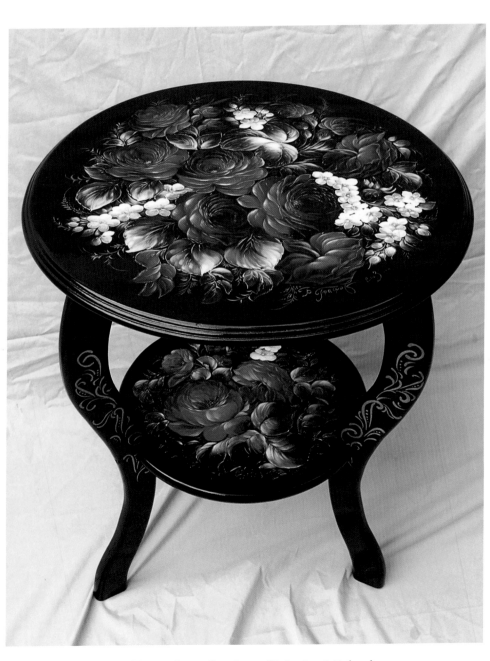

From the collection of Movita Michael

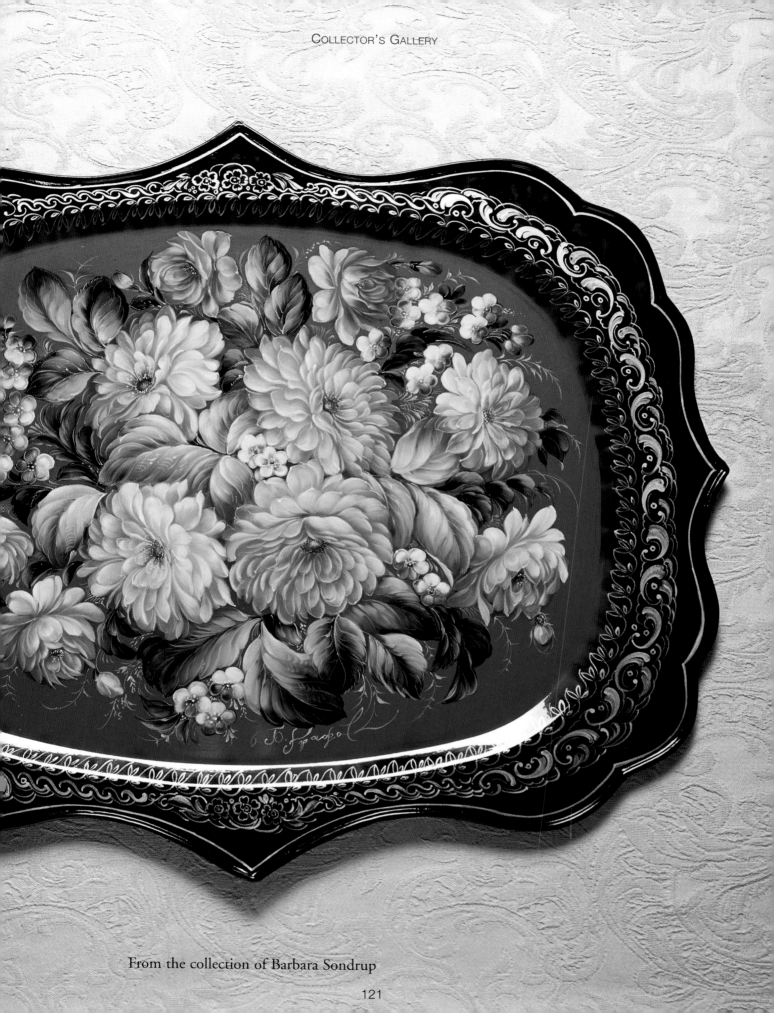

From the collection of Barbara Sondrup

A Long Tradition

The Vehnyakov brothers, former serfs, opened the first decorated tray workshop in Zhostovo in 1825. The craft was based upon the designs of lacquered papier-maché articles that were popular in the 18th and early 19th centuries. Zhostovo artists created their own style, with bouquets of colorful flowers as their usual subject. From the beginning, the trays were prized for their beauty; they were hung on walls and displayed on shelves. The tradition continues as collectors decorate their 21st century homes with these radiant folk art bouquets

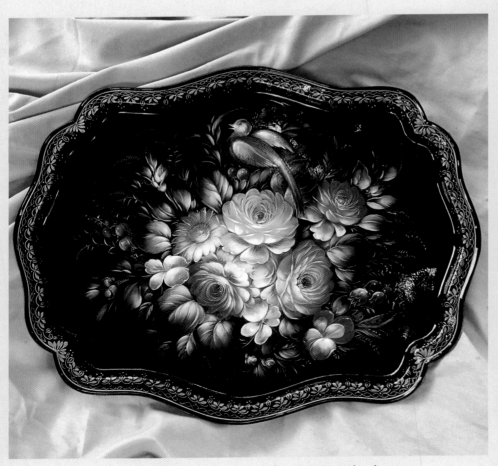

From the collection of Movita Michael

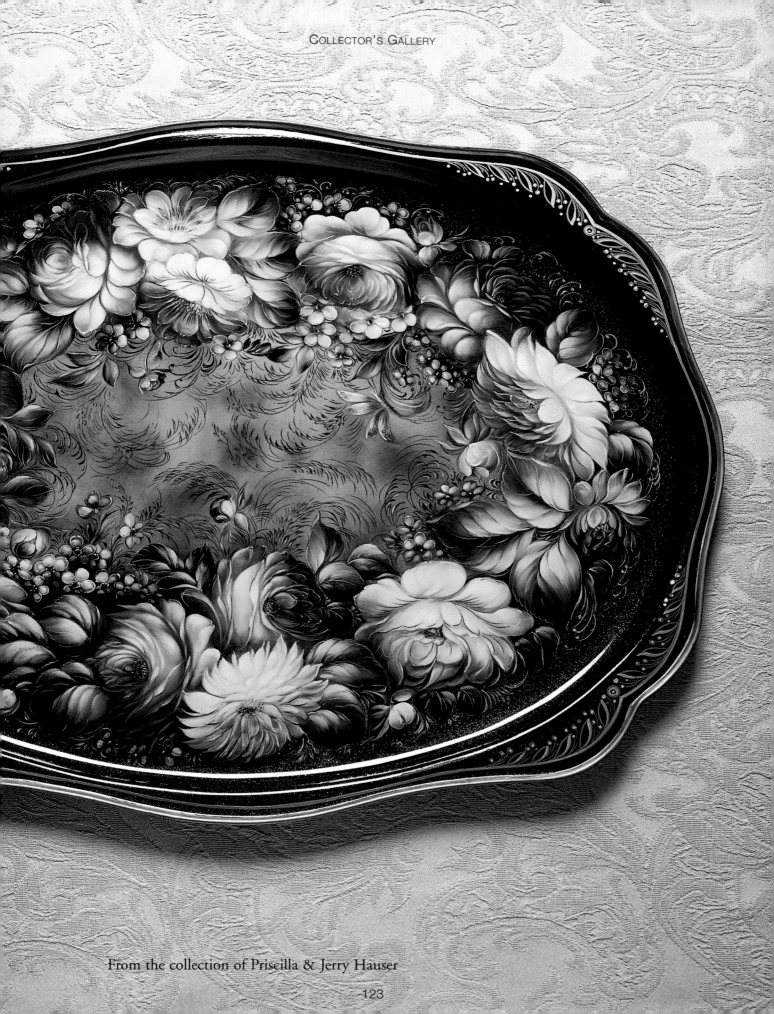

From the collection of Priscilla & Jerry Hauser

From Reality to Folk Art

Although the artists know the structure and colors of the flowers they work into their designs, they do not wish to paint a rendering of the natural flower. Folk art combines the imaginary with the real to produce convincing blossoms that are more splendid and colorful, more festive and joyful, than anything that grows in the garden.

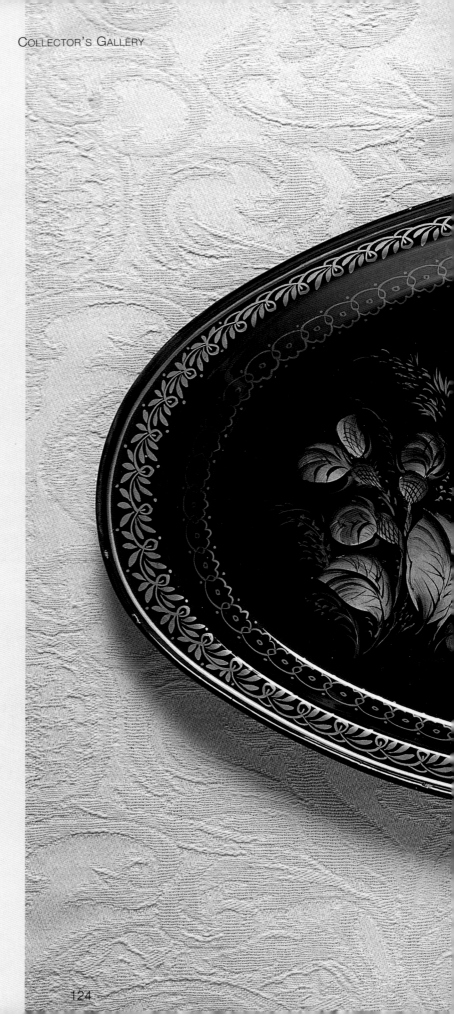

From the collection of Cordelia Dickson

Index (Continued)

Index

Continued on next page

Metric Conversion

Inches to Millimeters and Centimeters

Inches	MM	CM	Inches	MM	CM
1/8	3	.3	2	51	5.1
1/4	6	.6	3	76	7.6
3/8	10	1.0	4	102	10.2
1/2	13	1.3	5	127	12.7
5/8	16	1.6	6	152	15.2
3/4	19	1.9	7	178	17.8
7/8	22	2.2	8	203	20.3
1	25	2.5	9	229	22.9
1-1/4	32	3.2	10	254	25.4
1-1/2	38	3.8	11	279	27.9
1-3/4	44	4.4	12	305	30.5

Yards to Meters

Yards	Meters	Yards	Meters
1/8	.11	3	2.74
1/4	.23	4	3.66
3/8	.34	5	4.57
1/2	.46	6	5.49
5/8	.57	7	6.40
3/4	.69	8	7.32
7/8	.80	9	8.23
1	.91	10	9.14
2	1.83		

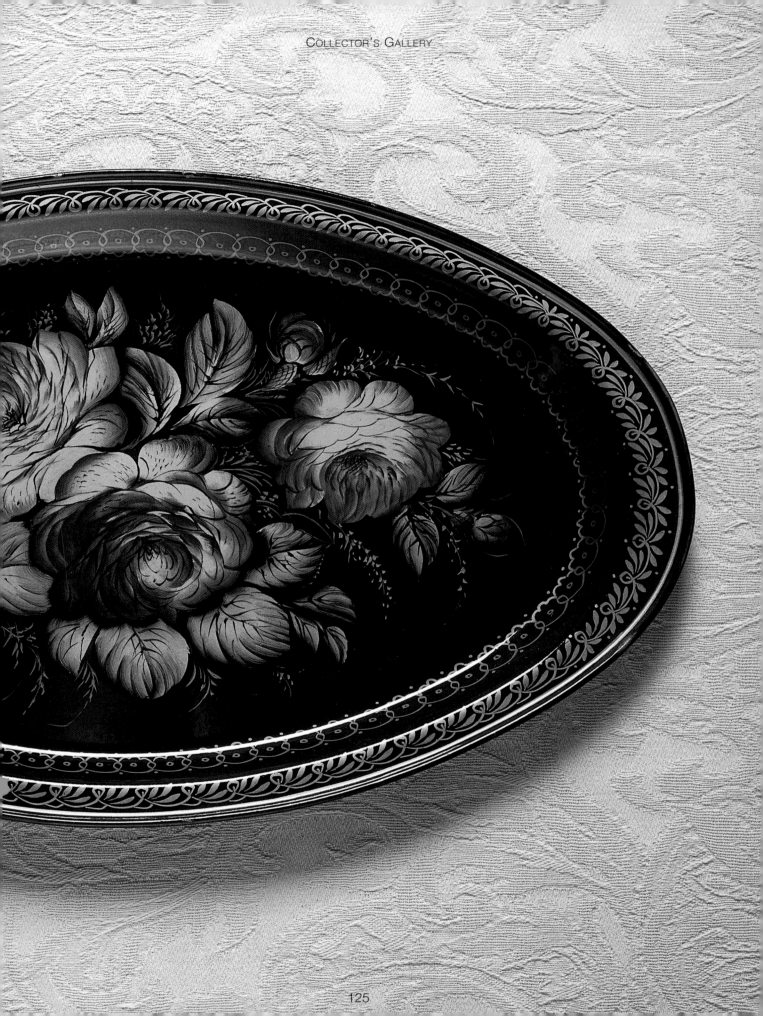